LEGENDARY LOCALS

OF

ENCINITAS

CALIFORNIA

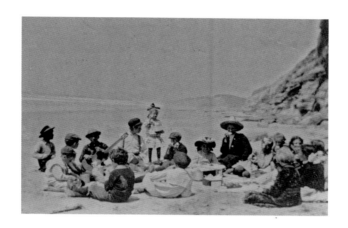

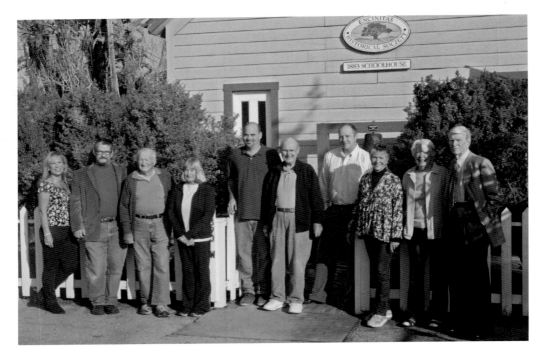

Encinitas Historical Society Board Members 2012
This photograph was taken on the steps of the 1883 schoolhouse, the oldest building in Encinitas and home of the Encinitas Historical Society. From left to right are Alison Burns (author), Tony Kranz, Jay Williams, Pam Walker, Kevin Post (vice president), Lloyd O'Connell, Sean Englert (president), Carolyn Cope, Connie McIntire, and Dr. Fred Harrison.

PAGE 1: School picnic
Long before the surfers and sun worshippers discovered Moonlight Beach, the children would make their way from the 1883 schoolhouse, which sat high on a bluff overlooking the Pacific, to picnic on the sands below. The following can be identified in this 1910 photograph: Lyle Hammond (holding guitar), Lyndon Thebo (head turned), Donnie Nipp, Carmen Valensevello (wearing sombrero), Mary Lux (ribbons in hair), Marguerite Lux and Helen Cozens. (Courtesy of EHS.)

LEGENDARY LOCALS
—— OF ——

ENCINITAS

CALIFORNIA

ALISON BURNS

LEGENDARY
LOCALS

Published by Legendary Locals, an imprint of Arcadia Publishing
Charleston, South Carolina

Printed in the United States of America

Library of Congress Control Number: 2011938419

For all general information, please contact Arcadia Publishing:
Telephone 843-853-2070
Fax 843-853-0044
E-mail sales@arcadiapublishing.com
For customer service and orders:
Toll-Free 1-888-313-2665

Visit us on the Internet at www.arcadiapublishing.com

Dedication
To all the extraordinary people of Encinitas who never even realized what legends they are: I hope this book goes some way to convincing them.

On the Cover: From left to right:
(TOP ROW) Maggie Houlihan and Pam Slater-Price (Courtesy of Dorell Sackett; see page 57), Magdalena Ecke (Courtesy of the Ecke Family; see page 30), Lloyd O'Connell (Courtesy of Lloyd O'Connell; see page 53), Max Kleckner (Courtesy of Aaron Feldman; see page 81), David Brin (Courtesy of Cheryl Brigham; see page 120).
(MIDDLE ROW) John Bumann (Courtesy of Bumann family; see page 13), Charlie Chaplin (Courtesy of Lola Larson; see page 117), Marion Ross (Author's collection; see page 110), Captain Book (Courtesy of Jan Jackson; see page 71), Dylan (Author's collection; see page 77).
(BOTTOM ROW) Stuart Grauer (Courtesy of Stuart Grauer; see page 75), Man from Mars (Courtesy of the San Dieguito Heritage Museum; see page 45), Ida Lou Coley (Courtesy of the Encinitas Historical Society; see page 40), Surfing Madonna (Courtesy of Fred Caldwell; see page 125), Bob Cozens (Courtesy of Cozens family; see page 37).

CONTENTS

ACKNOWLEDGMENTS

How to thank so many people who made this book possible? From the ones who invited me into their homes and sent me home with their precious family photographs—not to mention guavas, figs, and apples—to wonderful Trish the Dish who read poetry to me over the phone. By far the greatest benefit for this recently arrived English girl out of Asia has been getting to know so many remarkable people. Everyone was so generous, not just with me, but also with each other. If I went to see one person, they would mention another couple of names and those people would then suggest a few more. I was entranced at how in this city of over 60,000 people, everyone still seems so connected—how a visit to Captain Keno's bighearted owner, Gerry Sovo, led me to the artist who painted his portrait, who in turn gave me the phone number of an illustrator in the surfing community . . . and so it continued. Here we are well into the 21st century and yet nothing has really changed since the early pioneers came to Encinitas and helped one another fulfill their dreams.

But my greatest thanks goes to a few very special people, especially Lloyd O'Connell, my personal Wikipedia, who fielded all my historical questions with great equanimity. Once I'd worked out that he answered his e-mails early in the morning, I spent my nights firing off questions to greet him at breakfast. I hope I didn't give him too much indigestion. Everyone at the wonderful San Dieguito Heritage Museum was always infinitely patient with me, and Bob Bonde, who spearheaded the city's incorporation in 1986, helped immensely with his personalized Incorporation 101 tutorial. The legendary Fred Caldwell didn't seem to mind in the least how often I bothered him, Lois Aufmann pored over my final manuscript with diligence and grace, and Carolyn Cope, a living legend and pretty to boot, was kind enough to turn my English English into American English. I only hope that Maggie Houlihan, who was dealing with a deadline of her own, knew just how much I appreciated all her help and enthusiasm.

Thank you, everyone, for your patience and guidance. When you think of Encinitas, you automatically think of beaches and bars and boathouses, but it is undeniably its people that really make it work.

Abbreviations: Encinitas Historical Society (EHS) and San Dieguito Heritage Museum (SDHM).

INTRODUCTION

When E.B. Scott brought his family to Leucadia in late 1883, he fully intended to regard the trip as simply a pleasant vacation "if things were not satisfactory." But they never did move on: almost immediately the "cool and pleasant ozone breezes and beauties of white, pink, yellow and gold wildflowers scattered everywhere around our future home" had captured his heart. It was obviously good fertile land but, nevertheless, he decided to accelerate the process of attracting additional settlers by uprooting his neighbor's well-established eucalyptus trees and planting them, disguised with fresh soil, in full view of his East Coast prospects. They could then witness for themselves how well Leucadia saplings thrived in the space of a year.

Forty years later, Paul Ecke Sr. had no need to be persuaded by devious salesmen or transplanted foliage. Nestled between Batiquitos and San Elijo lagoons along six miles of Pacific coastline, Encinitas was as close to perfect as Ecke could have wished for. By the early 1920s, his Hollywood poinsettia

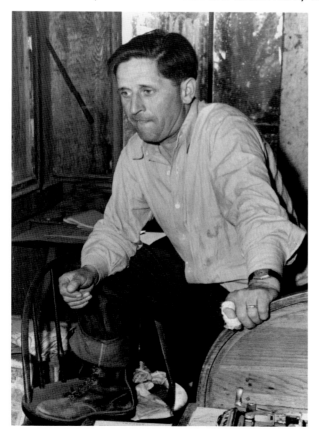

business had become so successful that he was looking to expand. He had already decided that this crimson plant's winter blooming cycle made it the ideal holiday flower, and he wanted to be the one to capitalize on its potential. Encinitas offered excellent rail links, the water supply was plentiful thanks to the recently opened Lake Hodges dam, and the Encinitas climate was almost identical to the poinsettia's indigenous Mexican locale. In 1923, Ecke relocated his business to the warm and welcoming town of Encinitas and concentrated on growing a poinsettia cultivar as an indoor potted plant. The story of how one man with vision turned a fragile and temperamental field plant into a world-renowned flower of commercial strength is also the story of the growth of Encinitas and its status as the poinsettia capital of the world. Recognized as the embodiment of floriculture, the town quickly attracted many more flower growers and the industries that supported them.

Paul Ecke Sr.
See page 28.

Encinitas is actually five distinct communities—a place where Aristotle would have been happy to apply his dictum that the whole is greater than the sum of its parts. The ideal Californian coastal city with its surf, sand, and sunshine, Encinitas provides all the essentials for its residents to cheerfully live, work, and play. In 1986, the five communities that comprise the City of Encinitas removed themselves from the authority of San Diego County and voted to be incorporated as one. In the ensuing quarter century, all five have remained fiercely protective of their uniquely individual identities: each community maintains a town council whose representatives address the five-member Encinitas City Council on their separate issues but work together on the bigger ones. It could even be said that cityhood has allowed Encinitas to find and establish its true identity.

At the center of the five communities is Old Encinitas, home of the business community, city hall, an impressive library, and one of the nation's best family YMCAs. Its downtown area is just blocks from Moonlight Beach, so called because of the small white rocks that used to glow like moons at night. Or you may prefer the more prosaic version, which holds that this beach was actually named for the moonshiners who rowed their alcohol-laden boats to shore during the Prohibition era.

Laid-back Leucadia, just to the north and bordering Batiquitos Lagoon, works hard to uphold its motto, "keep Leucadia funky"—although this mostly applies to its thriving arts community, eclectic restaurants, surf shops, and enticing antiques stores dotted along Highway 101. The fabulously expensive Pacific-view homes teetering on the bluff are perhaps more impressive than funky, while the beach below provides exceptional surfing and jogging—depending on whether the tide is in or out.

High up in the hills stands Olivenhain, vastly different from the other four parts that make up the whole. In fact, it is so detached that some have dubbed it "Oh-leave-us-alone-hain." Stretching away from the coastline, this semi-rural community is known for its horses—along with llamas, sheep, and pot-bellied pigs—with trails that wind through canyons and upscale housing developments. But at the heart of Olivenhain, you will still find the 1894 meeting hall, echoing with the accented voices of long dead German colonists, and its old wooden notice board where colorful birthday greetings and other eye-catching family announcements flutter like pennants in the wind.

Perhaps more than most, Cardiff-by-the-Sea, with its own library and zip code, has managed to maintain a certain autonomy. It also has the "Cardiff Kook," posed next to the celebrated Cardiff Reef where surfers from around the world come to confront some of the country's most challenging, and gratifying, waves. Originally intended to represent a novice surfer, the little bronze sculpture has been so pilloried by the surfing community that it spends its time either being totally ignored or dressed up in lavish attire. As such, it surely garners more attention than was ever intended. To the south, the coastal wetlands of San Elijo ecological reserve form the southern edge of the City of Encinitas.

New Encinitas once comprised farms and flower fields where lima beans grew in abundance and barefoot boys led cattle across what is now busy El Camino Real. This fifth, and newest, community is separated from Old Encinitas to the west by a low coastal ridge, while over to the east, by the Olivenhain border, the Scott family home sits high on a hill, boasting a 360-degree view of what was once Scott Valley and Green Valley. With the farms and flowers gone, the house now looks over to a home improvement monolith, a 520,000-square-foot shopping mall, and vast modern neighborhoods that house many of the city's 60,000 citizens.

The early settlers who struggled so hard to earn a living out of this virgin land would be amazed to see how their efforts have paid off. The pioneers who arrived in the early 1880s, and those later ones who crowded in during the rapid growth of the 1920s, instinctively understood exactly what Ida Lou Coley voiced many decades later, that Encinitas is the place "where reality meets magic."

The actress Marion Ross still maintains the house her mother bought in Cardiff-by-the Sea, 60 years ago, for $5,000. Although no longer a full-time resident, Ross has always returned for Cardiff's high days and holidays. During her July 2011 visit, when she presided over the town's centennial celebrations as grand marshal, she remarked that Cardiff hadn't lost any of its essence or sweetness. Then turning to a member of its town council, she quietly said, "you've taken good care of it."

If the early pioneers were to return now and look around at the Encinitas they worked so hard to create, they would doubtless say the same.

CHAPTER ONE

The Legend Begins

Stepping off the train at the downtown Encinitas whistle stop in 1883, the immigrant Hammond family was so stunned to find that their promised land of milk and honey had all been a figment of some adman's imagination, they asked the conductor to hold the train while they searched for the town's mythical 500 inhabitants. In the end, they decided to stay, but as the train pulled out, its fireman was heard to remark, "there's another family of greenhorns come here to starve."

A few miles up the coast, English spiritualists seeking religious freedom had already begun to settle Leucadia (Greek for "place of refuge") while, to the east, German colonists, much like the disenchanted Hammonds, were about to discover that their dream of planting olive groves on land so optimistically named Olivenhain would soon turn into a nightmare.

Further south, along the San Elijo lagoon, a Scottish Civil War veteran named Hector Mackinnon was also struggling to make a go of homesteading. Finally, in 1911, he was forced to sell off part of his 600 acres to Frank Cullen, a land developer, who named the area Cardiff-by-the-Sea in honor of his Welsh heritage.

The fifth region that now makes up modern day Encinitas was known in the days of the early pioneers simply as Green Valley, farmed by families like the Scotts and Cozens who still live and work close by. Over the next hundred years, it broadened and developed to become what today we call New Encinitas.

Life at the end of the 19th century and beginning of the 20th was tough for these newcomers—new not only to the vast uninhabited spaces of California but America itself. Hailing mostly from European cities, they had no idea what each year might bring, knowing only that they needed to persevere. It is this unrelenting determination and optimism, handed down through the generations, and bolstered by the resolve and vision of subsequent newcomers, that has made Encinitas what it is today.

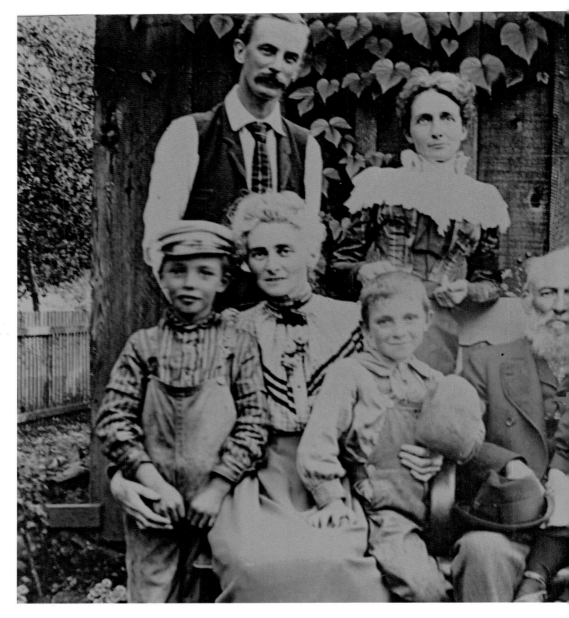

The Hammonds
This 120-year-old photograph shows Ted Hammond (top left) with his wife Mary; their children Lyle, Sam, and Janie; Mary's parents, the Thompsons; Ethel Crawley; and Sally Smythe. It is said that the Hammonds, originally from the north of England, doubled the town's population when they stepped off the train in 1883. With seven children in their party of 11, one of their highest priorities was to get them into school, which Ted and his father, E.G. Hammond, built between them. The one-room schoolhouse, now home to the Encinitas Historical Society, is still the oldest building in town. It was some time before cemeteries were built, so the first generation of Hammonds and Thompsons were simply buried in the Encinitas soil, in unmarked graves. (Courtesy of EHS.)

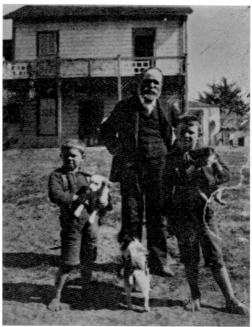

The House That Hammond Built
With so few other residents in Encinitas, the Hammonds had the pick of sites for their new home. E.G. Hammond, a cabinetmaker, named his ocean-view house "Sunset Ranch" for its wonderful sunsets. He is pictured here in about 1900 with grandsons Bert and Harold Cozens. (Courtesy of EHS.)

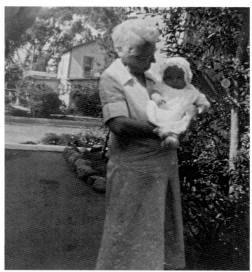

Grandma Hammond
In this photograph from the late 1930s, Mary Hammond is holding Sam Hammond's newborn daughter, Pamela. Following in the family tradition, Pam Hammond Walker today works tirelessly for the community as a docent at both the San Dieguito Heritage Museum and Encinitas Historical Society, and as an essential component of Meals on Wheels. (Courtesy of Pam Walker.)

Dress Code
Pam Walker with her father Sam Hammond in 1940. Looking back on old photographs, in the light of how laid back Encinitas has become, it is hard to recall a time when men felt compelled to wear a hat and three-piece suit to visit the zoo in the middle of a San Diego summer. (Courtesy of Pam Walker.)

School Days
This 1900 photograph bears testament to the early pioneer families whose lives have been so closely interwoven since the late 19th century. In the front row are the Woodward and Lux children, and behind them, the Cozens and Hammonds. More than a hundred years later, these names still echo in Encinitas today. (Courtesy of EHS.)

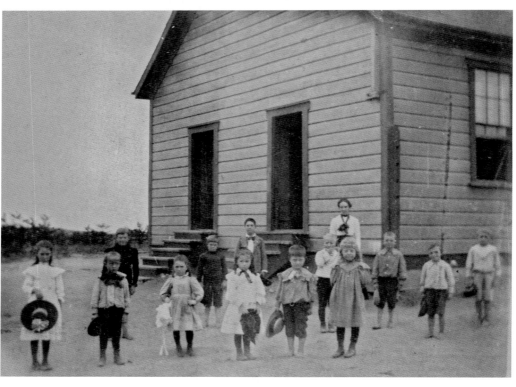

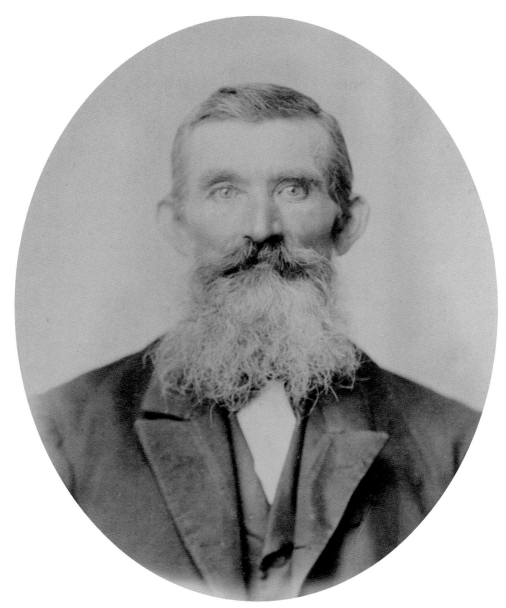

Colony Olivenhain

In October 1884, a group of 67 German immigrants, already calling themselves "Colony Olivenhain," bought a 4,431-acre Mexican rancho 25 miles north of San Diego with the intention of establishing a German settlement. Within six months of their November arrival, the colony had grown to 300 people. But it had also begun to unravel: the settlers discovered they had been cheated by the men brokering their purchase, and worse, that there was insufficient water to cultivate their vineyards and orchards. By January 1887, the colony was virtually abandoned. John Bumann (pictured) who was homesteading a mile east, encouraged his nephew Herman F. Bumann to do the same. Fortunately, Conrad Stroebel, one of the colonists who had defrauded his neighbors, was so anxious to leave that he transferred his homestead claim to Herman Bumann for $50. (Courtesy of the Bumann family.)

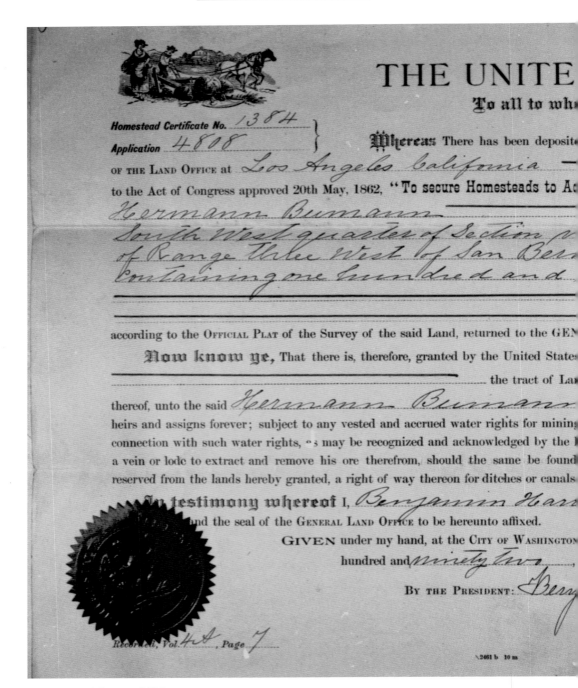

THE UNITE

To all to wh

Homestead Certificate No. *1384*

Application *4808*

Whereas There has been deposit

OF THE LAND OFFICE at *Los Angeles California* —

to the Act of Congress approved 20th May, 1862, "To secure Homesteads to Ac

Hermann Bumann —

South West quarter of Section

of Range three West of San Ber

Containing one hundred and

according to the OFFICIAL PLAT of the Survey of the said Land, returned to the GEN

Now know ye, That there is, therefore, granted by the United State

———————————————————————— the tract of La

thereof, unto the said *Hermann Bumann*

heirs and assigns forever; subject to any vested and accrued water rights for minin

connection with such water rights, as may be recognized and acknowledged by the

a vein or lode to extract and remove his ore therefrom, should the same be found

reserved from the lands hereby granted, a right of way thereon for ditches or canals

In testimony whereof I, *Benjamin Har*

and the seal of the GENERAL LAND OFFICE to be hereunto affixed.

GIVEN under my hand, at the CITY OF WASHINGTON

hundred and *ninety two*

BY THE PRESIDENT: *Ben*

Recorded, Vol. *4A*, Page *7*

2461 b 10 m

Homestead Patent 1892

After the requisite five years spent improving his 160-acre homestead, and with several neighbors acting as witnesses, Herman F. Bumann was awarded a patent under the 1862 Act of Congress "To secure Homesteads to Actual Settlers on the Public Domain." The land was his in perpetuity to hand down to future generations. (Courtesy of the Bumann family.)

14

(4—403 a.)

STATES OF AMERICA,

hese presents shall come, Greeting:

he GENERAL LAND OFFICE of the United States a CERTIFICATE OF THE REGISTER

———————————————————————————— , whereby it appears that, pursuant

Settlers on the Public Domain," and the acts supplemental thereto, the claim of

———————— has been established and duly consummated, in conformity to law, for the

e in Township thirteen South

a dine Meridian in California

fty acres

LAND OFFICE by the SURVEYOR GENERAL:

the said *Hermann Beemann*

ve described: **To have and to hold** the said tract of Land, with the appurtenances

————————————————————— and to *his*

:ultural, manufacturing, or other purposes, and rights to ditches and reservoirs used in

:stoms, laws, and decisions of courts, and also subject to the right of the proprietor of

netrate or intersect the premises hereby granted, as provided by law. And there is

ucted by the authority of the United States.

~~, PRESIDENT OF THE UNITED STATES OF AMERICA, have caused these letters to be

fifth day of *January*, in the year of our Lord one thousand eight

f the Independence of the United States the one hundred and *sixteenth*

ni Harrison

By *M. McKean*, Secretary.

D. P. Roberts

Recorder of the General Land Office.

15

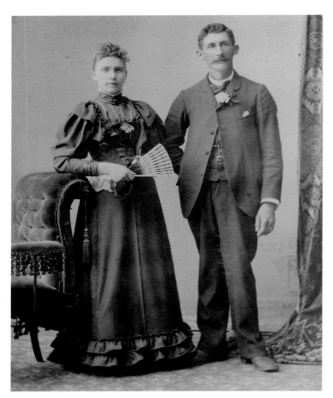

Emma and Herman

Herman F. Bumann met divorceé Emma Junker in early 1893 and began a long-distance courtship, often making the 30-mile journey on horseback. The photograph shows their wedding day, December 20, 1893, when the city girl traded the bright lights of 19th-century San Diego for the life of a homesteader's wife on the arid Olivenhain land. (Courtesy of the Bumann family.)

Children

Emma Junker came into her marriage with one child, Selma, and by 1914 had produced another 12. When the seventh baby was on the way, Herman Bumann constructed a children's bunkhouse divided into two rooms: the south for the boys and the north for the girls. All the children were expected to help on the ranch—before they left for their two-mile barefoot walk to school, and again on their return.

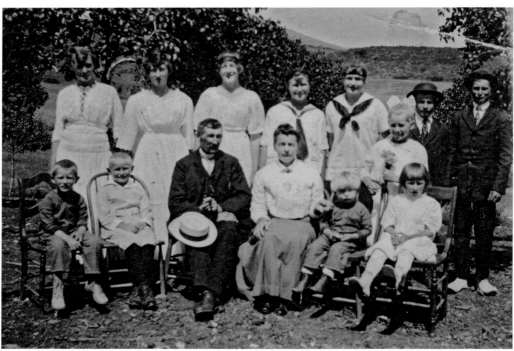

Mischievous Boys

Bill and George, pictured around 1921, were the youngest of the Bumann children. One day, discovering their father's dynamite caps, they started throwing rocks at them and were having great fun until a piece of shrapnel lodged in George's neck. By the time the bleeding had stopped, his shirt was soaked in blood. Herman's reaction put an end to further experiments with explosives. (Courtesy of the Bumann family.)

Honoring the Past

In 1936, the Bumann ranch was divided among all 12 children. Only Herman C. Bumann remained, gradually buying land back from his siblings. Today his nephew Richard and wife Adeline live there, custodians of a past that is really only sleeping—open the barn doors and there you will discover the old farm machinery, carriages, even a Model T, glinting in shafts of ancient sunlight, while nearby Herman's house looks much as it did a century ago. (Author's collection.)

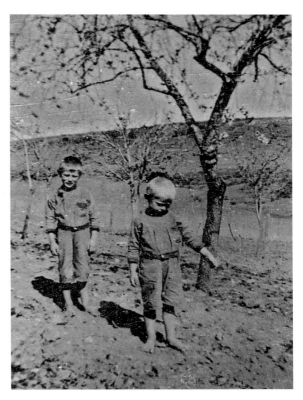

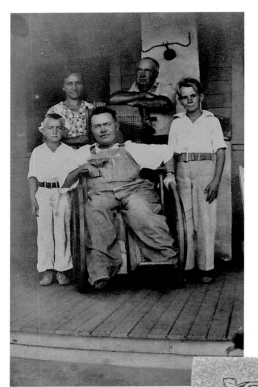

Scott Valley
When English immigrant Frank Lucas Scott married Adam and Christiana Wiegand's daughter Elizabeth, he brought with him a boy named Wayne (shown with his parents and two half-brothers George and Richard in 1934), who was confined to a wheelchair and died in his teens. Their 350-acre farm extended from El Camino Real to what is now Olivenhain Storage. (Courtesy of the Scott family.)

Pioneer's Grave
F. Lucas Scott died in 1948 and is buried at the Colonists' Cemetery on the old Denk/Wiro property in Olivenhain. His wife and stillborn daughter, known only as "Baby Scott—1922" lie close by. Emelie Mobus Hauck became the cemetery's first resident in 1891, and the only one to be buried in a northerly direction. The 1.9-acre site, reserved solely for the colonists and their direct descendants, is still maintained by their families, even to the point of digging their loved ones' graves. (Author's collection.)

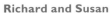

Richard and Susan
This 1950s photo shows Richard Scott holding baby Susan, the first of his three daughters, while behind him, Scott Valley's fields of lima beans and barley stretch out beyond the horizon. For many years, Scott supplied the beans for the San Dieguito Heritage Museum's annual Lima Bean Festival, and was honored at their 2011 celebrations for all his past generosity. (Courtesy of the Scott family.)

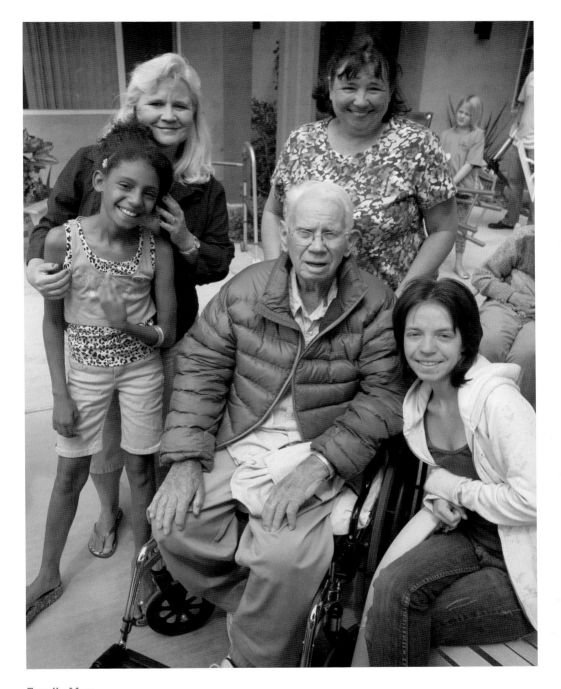

Family Man
This was taken in 2011 at the Olivenhain Rest Home, just a few miles from where Richard Scott was born in 1926 and where he spent a lifetime farming his fields. His daughter Susan still lives in the house that her parents built in 1968, high on a hill. Pictured left to right are Richard's daughter Barbara, granddaughter Shadia, Susan, and granddaughter Rebecca. (Courtesy of the Scott family.)

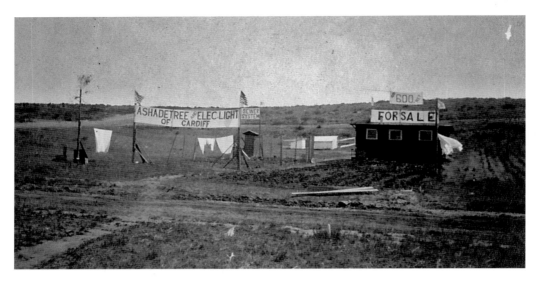

Cardiff in the 1930s
In addition to working on his own property, F. Lucas Scott often graded roads to generate more income. In the 1930s, Cardiff-by-the-Sea was just beginning to be developed and property was cheap. The shack and land (dimensions unspecified) were for sale at $600. (Courtesy of the Scott family.)

The Teten House
John Teten moved to Olivenhain in 1892 and married Laura Bumann in 1917. Their third child, Gladys Teten Schull (pictured), can point to the exact window—upstairs, east—of the room where she was born in 1926. The house, which was originally located a short walk from the Olivenhain Meeting House, is now part of the San Dieguito Heritage Museum. (Author's collection.)

Wiegand Family
This 1937 photograph of Virginia Wiegand shows how unpopulated Olivenhain used to be. Virginia's grandparents Adam and Christiana Wiegand were German immigrants who put all their hopes into Colony Olivenhain only to find that their land deed was worthless. After abandoning the colony, they filed for a 160-acre homestead on the east side of Aliso Canyon. (Courtesy of the Scott family.)

The Haucks
Herman Otto Hauck emigrated from Germany in 1853 and met and married Emelie Mobus in the United States. They were one of the first to join Colony Olivenhain in 1884 but became disenchanted and moved to Vista. In 1888, they decided to try Olivenhain again. This house was constructed on the southwest corner of Rancho Santa Fe Road and what is now Whisper Wind Drive. (Courtesy of EHS.)

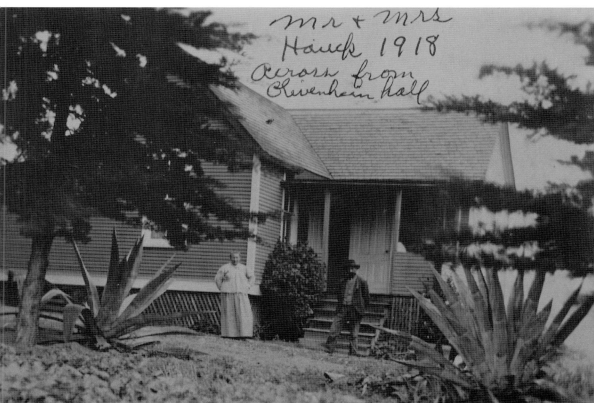

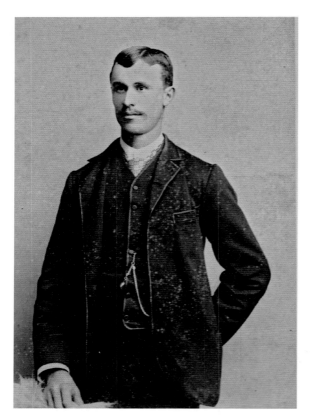

Peter Lux
The first of three brothers to emigrate to America from Luxembourg, Lux settled in Encinitas around 1885. He was a successful dry farmer and beekeeper and was deeply involved in the welfare and development of his adopted town. His 1925 obituary, at age 63, speaks of him as "one of the few who braved the hardships of pioneer life to make Encinitas what it is today." (Courtesy of EHS.)

Lux Home
In 1892, Peter Lux married Margareth Claud, an old friend from Luxembourg. Their five children were all expected to work hard on the family ranch. In fact, Alice Lux once told her teacher that she preferred school to home because it meant she could rest for a while. The picture shows the Luxes with their youngest child, Lawrence, at their home on First Street. (Courtesy of EHS.)

Lux and Wiegands Combine

The second Lux brother to arrive in Encinitas, around 1893, was John. His son, Alex, married Amelia, the daughter of another of the early pioneering families, the Wiegands. This 1920 photo shows Alex and Amelia with Grandma Lux holding baby Jesse. Alex, like the rest of his family, was a successful dry farmer in Green Valley. (Courtesy of the Scott family.)

The Lux Clan

Eventually all three Lux brothers—Peter, John, and Henry—settled in California and by 1932, when this photograph was taken up in the mountains, had become a large clan—one that apparently liked wearing hats. Anyone without a hat could take advantage of a nearby hand. The front row shows Robert, Herbert, and Jesse Lux. (Courtesy of the Scott family.)

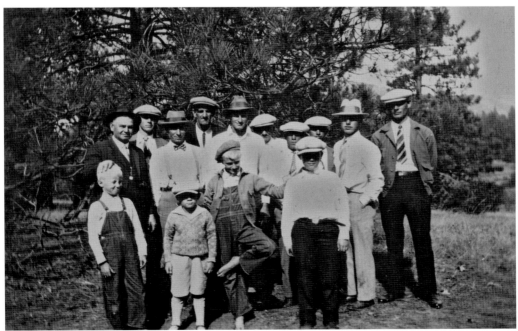

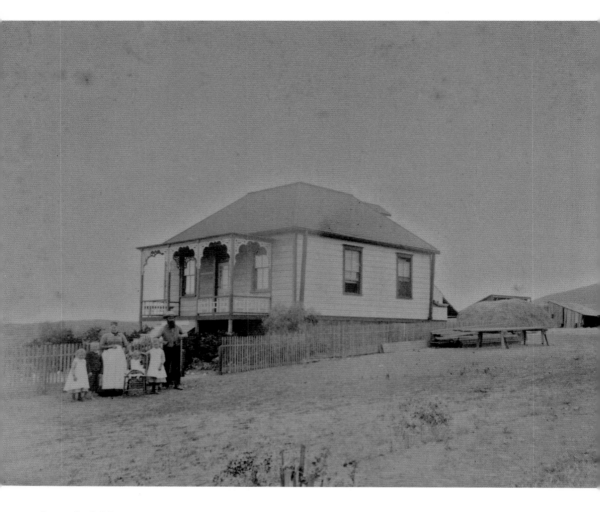

Lone Jack Hero

This photograph, taken around 1892, shows Bernhard Reseck and his wife Anna Brokop Reseck with Martha, Adolph, Fran, and Nellie—the first of their 11 children—at their 160-acre homestead on what is now Lone Jack Road. The house behind them burned to the ground in 1896: fire was always a constant threat in this part of Olivenhain.

Years later, the Resecks sold the property to a San Diego realtor named Muir who kept one donkey and a few cows on the ranch. One day fire broke out across the way and Muir rushed to save his cattle. Unfortunately, his only form of transport in this emergency was the donkey—his lone jack. Desperate to move the cattle out of harm's way, he steered the donkey toward a canyon, but the animal stubbornly refused to budge. The more Muir kicked, the more the jack dug in his heels. Just as he was losing all patience with the beast, a huge ball of fire exploded in the canyon: the donkey had saved his master's life (not to mention his own). Muir was so thankful for this delivery from certain death, he named the ranch after his savior.

Although the road leading up to Lone Jack Ranch was never officially named as such, it slowly became known as Lone Jack Road, remaining a dirt track until well into the 1970s. Nowadays it leads to some of the most opulent homes in Olivenhain—many of them built on the old Reseck homestead. (Courtesy of EHS.)

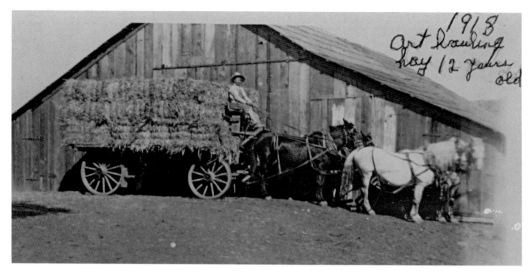

Cole Ranch

Art Cole was just 12 years old when this photo was taken in 1918. Years later, someone dared suggest he had just jumped onto the hay to pose for the camera. No, he protested, I hauled that entire wagon on my own. And loaded it too! Cole was one of three brothers, but the only one to remain farming in Olivenhain. When modernization looked inevitable, he bought a 1930s Farmall F12 tractor from Fritz Wiegand and delivered his beloved horses to the zoo. According to his sons, Cole cried all the way home. Like their father before them, Stan and Lynwood Cole have always been attached to the land. The photograph shows them with their father's old tractor on the Cole property. (Courtesy of EHS (top) and the author (bottom).)

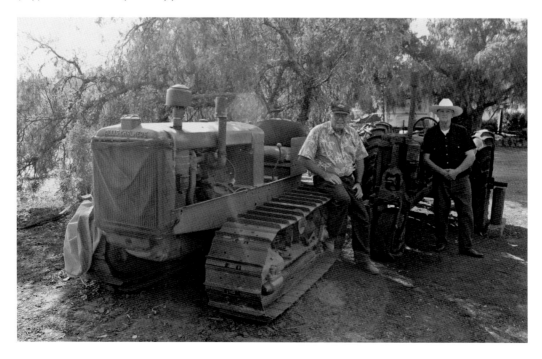

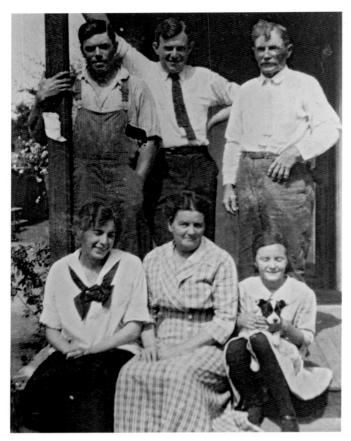

The Cozens

Annie Hammond was a small child when she arrived in Encinitas in 1883. She later married Ted Cozens and went on to write what is regarded as the definitive history of pre-1900 Encinitas. Pictured in 1916, she is sitting between Grace van Antwerp Cozens and her daughter Kathryn Cozens. Sons Bert and Harold and husband Tom stand behind her. (Courtesy of EHS.)

Grading Cardiff

It is almost impossible to imagine that this kind of equipment was once used to grade the roads of Cardiff-by-the-Sea. Sam Hammond and Bert Cozens, both grandsons of E.G. and Jane Latchford Hammond, began by using horses for their grading and lot leveling business, but were able to modernize with trucks and tractors, as they grew more prosperous. (Courtesy of EHS.)

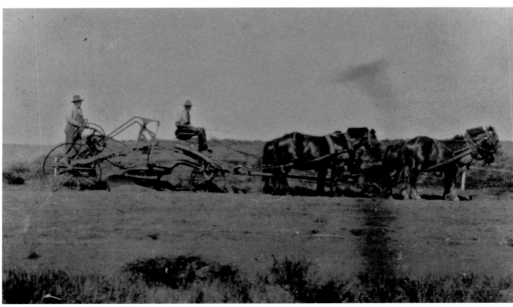

Hunting 1914

This carefree photograph was taken the year war broke out in Europe. It would be another three years before America sent its sons overseas to fight Kaiser Bill. In this picture, Bert Cozens (left) and his father, Tom, are taking their dog out for a day's hunting. Note the right-hand drive car. (Courtesy of EHS.)

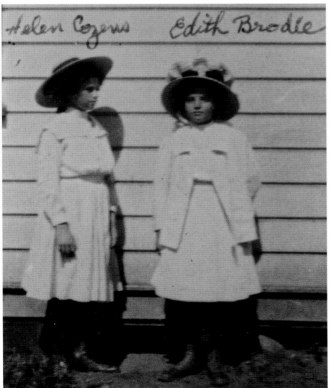

Cozens Cousins

The Cozens quickly became one of the most prominent families in downtown Encinitas and by 1887 owned a land office on First Street selling real estate—a profession continued into the 21st century by Tom and Peggy Cozens. Shown outside the schoolhouse are Helen Cozens (left), daughter of Charles and Alice Cozens, and her cousin Edith, whose mother was Alice's sister, Ella. (Courtesy of EHS.)

Poinsettia King

German immigrant Paul Ecke was just 24
when, in 1915, he took over the family ranch
in Hollywood, selling off dairy pasture to
concentrate on cultivating poinsettias. As
affordable land around Los Angeles became
ever more scarce, he turned to Encinitas,
where the climate was excellent, the water
supply good, and the railroad reliable.
Throughout his life, Ecke continued to
develop this relatively obscure field flower
into a highly successful indoor potted plant,
eventually introducing over 30 different strains
recognized throughout the world. Of the more
than 40 million poinsettias now sold annually in
the United States, the majority can be traced
back to Encinitas. Who could have known back
in 1923, when this hardworking farmer paid
just $6,000 for his first 40 acres, that he would
one day be dubbed the "poinsettia king"?

When Paul Met Magdalena

In her 1975 biography of Paul
Ecke, Vera E. Dutter describes
Magdalena Maurer holding "a
huge bouquet of scarlet blooms
and her dark eyes sparkling with
animation." When Ecke first
proposed, Maurer's parents
forbade the marriage since she
was only 19 and Paul 10 years her
senior. If they thought they had
extinguished the romance, they
were in for a shock: Ecke and
Maurer eloped New Year's Eve
1924. (Courtesy of the Ecke family.)

Paul Ecke Jr. (1925–2002)
For a family whose business involved promoting the quintessential Christmas flower, it was fitting that the man destined to take it to worldwide recognition should be born in December. Having worked on the family ranch since the age of 10, and with a degree in horticulture, Ecke was well qualified to steer the company forward to high-tech floriculture under glass. (Courtesy of the Ecke family.)

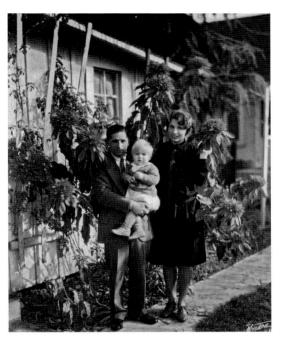

Validation
Despite her parents' dire warnings, Maurer's marriage to Ecke was a long and happy one, lasting until her passing in 1981 at age 76. This 1949 photograph shows the happy couple on their silver wedding anniversary surrounded by family. From left to right: William (Bill) Dealy, Ruth (Crix) Ecke Dealy, Paul Ecke Jr, Barbara Ecke Winter, and Ray Winter. (Courtesy of the Ecke family.)

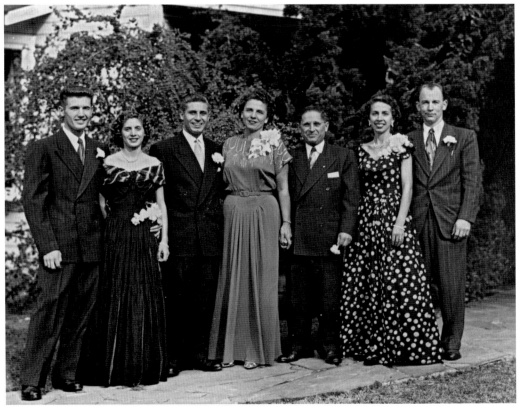

Magdalena

Although only two years old when she arrived in America, Magdalena Maurer Ecke never entirely abandoned her Swiss roots and was often asked to speak at women's groups about her native country, dressed in national costume. One very special memory for her grandchildren is being taken to Switzerland the summer after each graduated high school to go hiking in the Alps.

In an era when wives stayed at home, Ecke happily proved the old adage that behind every successful man is a clever woman. She was a true workhorse, looking after her husband and children while raising chickens, acting as bookkeeper and secretary, feeding the ranch hands, and caring for her German mother-in-law. In fact, Ecke was happier staying in the background: during the Depression years, she quietly dropped off homemade casseroles at the local community centers. And long after the California economy had bounced back, she remained deeply involved with a Mexican orphanage, driving across the border once a month, her car stuffed to the roof with as many essentials as she could squeeze in. Despite all the other demands on her time, Ecke loved to cook. Her baking was legendary, especially her cookies, and Tak Sugimoto, now in his 80s, still remembers sitting in her kitchen after school, being fed warm cookies and milk.

Both Paul Sr. and Magdalena Ecke grew up in an era that believed strongly in being involved in the community. During the Depression, the Eckes gave each of their workers a plot of land to grow vegetables and slaughtered cattle to provide beef for their families. When their Japanese neighbors were forced into internment camps during the war, only they and one other family offered to store their possessions. Paul and Magdalena instilled this same sense of obligation in their children—which has in turn been passed down to the present generation. Magdalena will always be remembered as someone who liked to help others, quietly doing good by stealth, and it is fitting that her name lives on in the Magdalena Ecke Family YMCA on land donated by her son. (Courtesy of the Ecke family.)

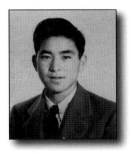

Takeo Sugimoto

When Franklin D. Roosevelt signed Executive Order 9066 shortly after the Pearl Harbor attacks, he condemned thousands of Japanese and their American-born children ("*nisei*") to years of forced internment in detention camps far from their homes. Fourteen-year-old Takeo Sugimoto, whose parents had farmed in Encinitas since 1925, never saw his father again after he, his mother, and siblings, were banished. Mr. Sagiro Sugimoto died of TB while his family languished in a detention camp in Arizona. His wife received only a small cardboard box containing her husband's ashes.

Because the Oriental Exclusion Act prohibited Asians from owning land, the Sugimoto family had only been able to lease their 50 acres until one of their sons turned 21. Like so many Japanese families, they lost everything when rent and taxes went unpaid during their enforced absence. What also disappeared were the guns, cameras, and radios that Sugimoto and his brother had naively entrusted to the police. But there was one bright spot: their neighbor, Paul Ecke Sr., himself a German immigrant and therefore in danger of coming under the spotlight, courageously offered to store his Japanese neighbors' possessions. Sugimoto remembers that when they returned at the end of World War II, they started their brand new life with nothing but the truck they had left with Ecke.

At 17, and still confined to the internment camp, Sugimoto wanted more than anything to graduate with his friends from San Dieguito High. His business teacher sponsored him and the request was put to a vote: all but one student agreed. Sugimoto was aware of the social gap that had widened after his three-year absence, but even so, he was greeted with a rousing cheer from all his classmates when his name was called at graduation.

Before entering the internment camp, Sugimoto's family had been told to destroy all their photograph albums in case the FBI should accuse them of spying. So the only picture that remains from the 17 years between Sugimoto's birth and graduation is the mugshot in his 1945 high school yearbook. Written next to it are the deeply moving words, "there's nothing half so pleasant as coming home again." (Courtesy of SDHM.)

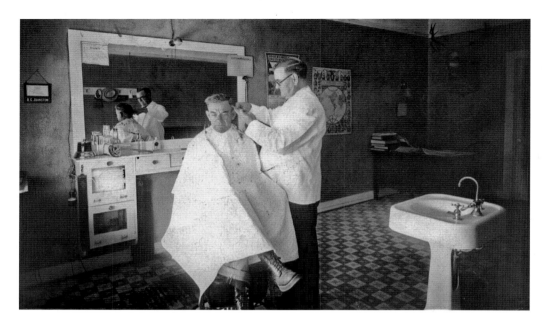

Al's Barber Shop

In 1920, Grant Ulysses Johnston won Al's Barber Shop in a game of cards, but rather than go to the expense of painting his own lengthy name over the door, decided instead to adopt his predecessor's. When his son Harvey joined him in 1932, they were known simply as Big Al and Al Jr.

Haircuts were 35 cents and shaves, 15 cents, although farmers were just as likely to pay in lima beans during the Depression. After the store closed in 1959, the family held onto its contents and have loaned everything to the San Dieguito Heritage Museum for their current exhibit, which opened October 1, 2011, on the city's 25th birthday. Al's great-granddaughter, Stephanie Cashion (left), and granddaughter, Candy Hayes (right), went along to relive old times. (Courtesy of Harvey Johnston family (top) and the author.)

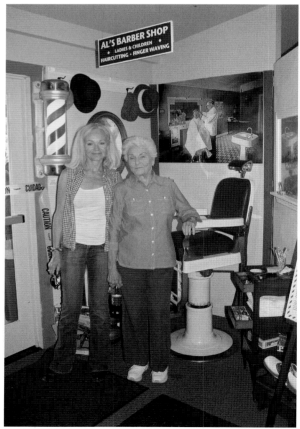

CHAPTER TWO

We Built
This City

Gradually, the little communities clustered around downtown Encinitas turned into something more distinctive and special. Film stars like Bessie Love and Charlie Chaplin built houses along the coast, and Paramahansa Yogananda chose Encinitas as the ideal place to site his ashram.

The Depression left its mark on the area: families drifted away as businesses failed, while others, like the Coleys, escaped the Oklahoma Dust Bowl and settled in Encinitas. War changed the demographics again when newly minted soldiers, sailors, and airmen left for the battlegrounds of Asia and Europe. Not all returned. Japanese residents, many of them American citizens who had worked for decades alongside their Encinitas neighbors, disappeared almost overnight after Executive Order 9066 forced them into internment camps.

By the 1960s, change was again in the air. By now, Encinitas was known as the Flower Capital of the World, thanks mainly to Paul Ecke Sr., while the coastline from Cardiff to Leucadia had become a famous surfing mecca. Water finally arrived in Olivenhain and farmers no longer had to rely on temperamental rain clouds. With water came a far more lucrative crop: where once there had been only rows of lima beans, residential homes started sprouting throughout the Olivenhain landscape.

Along the coast, neighbor fought neighbor over the positioning of the new freeway. Many were fiercely opposed to having it swallow up Highway 101, citing not only the ruin of businesses and the loss of housing, but the fact that such a major highway, so close to the bluff, was in danger of tumbling into the ocean.

The housing boom of the 1970s and 80s threatened to turn the once sleepy communities into a suburban hub. It was time to join forces, cut the cord with San Diego County, and become a city. Again, there was fierce controversy, but Bob Bonde, believing incorporation was the only answer, gathered his troops and turned his basement into a war room. Even when incorporation was inevitable, the name of the new city was still in doubt. Voters were asked to choose between Encinitas, San Dieguito, or Rancho San Elijo. Finally, on October 1, 1986, the five communities joined together and became the City of Encinitas.

Father of Encinitas

Bob Bonde was the driving force behind the city's 1986 incorporation and continues to be a tireless worker and community activist on many other grassroots campaigns. In declaring May 2, 2009 to be Bob Bonde Day, San Diego County supervisor Pam Slater-Price praised the retired university professor for his mentorship of a new generation and overall contribution to the betterment of Encinitas. (Courtesy of Bob Bonde.)

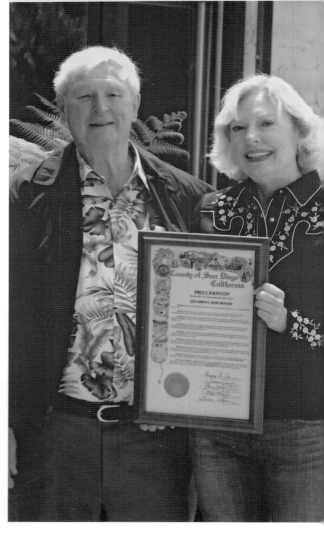

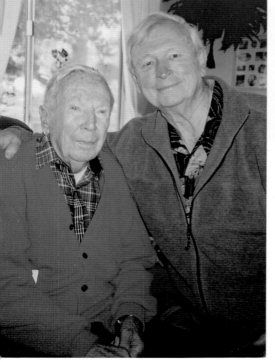

Volunteers

Although Bob Bonde was the chairman and inspiration of the North Coast Incorporation Coalition, he is adamant that the campaign would not have succeeded without the hard work and determination of its many volunteers. Bonde's book, *October 1, 1986: Independence Day*, contains an honor roll of around 200 people whose contribution was of paramount importance. He is pictured here with volunteer Walter Wallace. (Courtesy of Bob Bonde.)

Mother Cardiff

The volunteers take a rest in Bob and Joanne Bonde's basement, aka "the war room." Center is Pat Rudolph, nicknamed "Mother Cardiff" after she established its town council in 1977. Rudolph was once so incensed by a cut in city funds that she got a cherry picker to lift her up onto the town's flagpole and perched there in protest for almost 15 minutes. (Courtesy of Bob Bonde.)

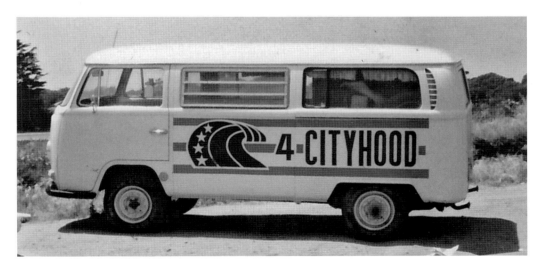

Success!

Some people pin their colors to the mast; others just let their campers do the talking. There was such violent opposition from some quarters to the idea of self-rule that it took six tries before a majority vote of 69.3 percent finally transformed the five disparate communities of Encinitas, Leucadia, Cardiff-by-the-Sea, New Encinitas, and Olivenhain into one city. (Courtesy of Bob Bonde.)

The City's First Mayor

The qualities that made Marjorie Gaines the city's first mayor also proved to be her undoing. Her celebrated no-nonsense style and enthusiasm were huge factors in guaranteeing the success of the campaign for incorporation and, in the race for mayor, she garnered more votes than the next two candidates combined. But her confrontational style also worked against her, and in 1990 Gaines was voted out of office. (Courtesy of Bob Bonde.)

Children's Champion

Although childless herself, Mildred MacPherson, former principal of Central School, always cared deeply for the students in her care, ensuring they were well fed even through the Depression years. Generations later, she is still remembered through the Mildred MacPherson Park on Vulcan Avenue and an enchanting waterfall in the San Diego Botanical Gardens that bears her name. (Courtesy of the Ecke family.)

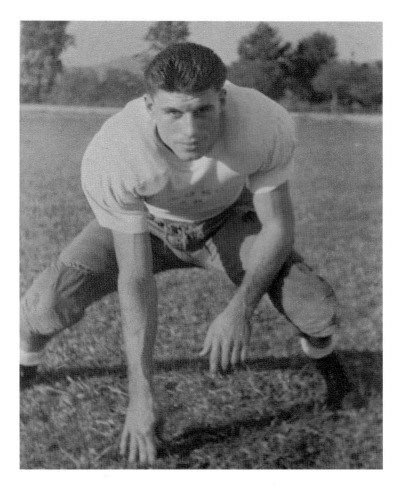

Public Service Personified

The Cozens family has a long history of being active in the community—and indeed the country—from the arrival in the early 1880s of Tom and Jimmy Cozens to the present. Bob Cozens (pictured during his college football years) is the great-grandson of E.G. and Jane Hammond, whose house, Sunset Ranch, was the indisputable social hub of late-19th-century Encinitas. Bob's grandmother, Annie, youngest of the seven Hammond children who emigrated from England in 1883, was married to Tom Cozens and known as a force to be reckoned with. A member of the board of trustees at the one-room Encinitas schoolhouse that grandson Bob attended up to eighth grade, Annie was also the author of *A Brief History of Encinitas*. Another major influence in helping shape Encinitas, Bob's father, Bert, owned a successful grading business that was vital to the development of Leucadia.

Bob Cozens first served his country at the age of 23 when, as a B-17 bomber squadron commander stationed in England, he flew 25 missions that earned him several medals including the Distinguished Flying Cross. Bert and Grace Cozens felt it their patriotic duty to send their sons, Bob, Tom, and Dick, overseas as part of the Army Air Forces, but the family paid the ultimate sacrifice when both Tom and Dick were killed in action. Bob went on to become the first county supervisor to be selected from Encinitas, a job he relinquished only when Ronald Reagan personally appointed him head of the Department of Motor Vehicles. Now in his 90s and long since retired, Bob looks back proudly on a life of public service—and far beyond that, to a time when he could still run barefoot among his father's horses and cattle on what is now El Camino Real. (Courtesy of Cozens family.)

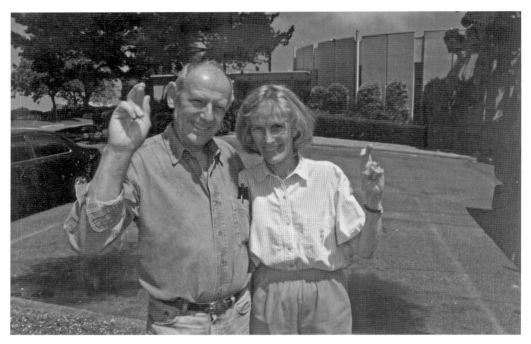

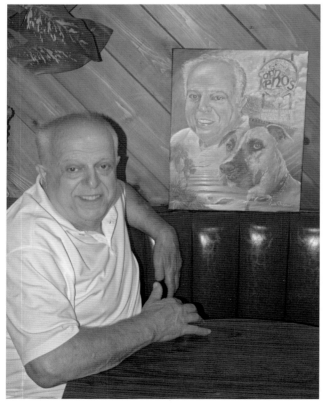

Fingers Crossed
Encinitas has Al and Marion Rowe to thank, in part, for the breathtaking view from the town's library. In 2002, the Rowes, along with Ida Lou Coley, fought the council's plan to site the new library inland. Their hard work in galvanizing the city's residents paid off: librarygoers today can stretch out on its terrace and gaze toward the wide blue Pacific. (Courtesy of the Rowe collection.)

Philanthropy Personified
Gerry Sova was delighted when local artist Kevin Anderson presented him with this portrait—not only because of its authenticity, but also because Sova is the one who usually does all the giving. Owner of Captain Keno's restaurant since 1970, Sova is renowned for his generosity during community benefits, but never more so than during Thanksgiving when paupers and millionaires alike pay just $3 for his legendary dinners. (Author's collection.)

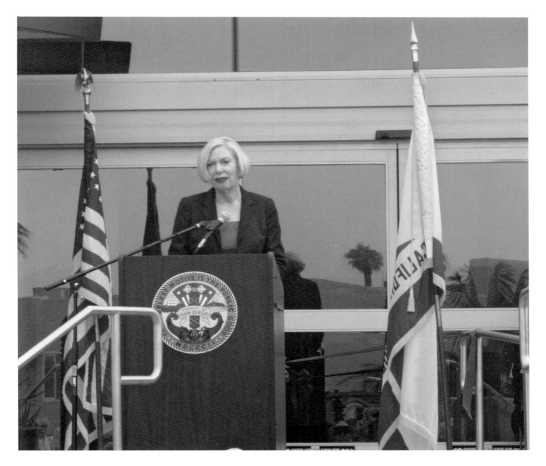

Making a Difference

When schoolteacher Pam Slater-Price first visited Encinitas in 1974, she was so attracted by the beauty and charm of this sleepy coastal town that she knew she wanted to be part of it. But as time went on she found herself growing disillusioned with the unrestrained way the county government, which at that time still oversaw Encinitas, was handing out building permits. Rather than stand by while unchecked development ran rampant, Slater-Price worked to get onto the San Dieguito Citizens' Planning Group, an advisory panel to the county Planning Commission.

By the end of the 1980s, she had moved into elected office, serving as one of the first councilwomen, and eventually mayor, of the City of Encinitas. In 1992, she was voted onto the San Diego County Board of Supervisors, where she will continue to represent several communities, including Encinitas, until she steps down in 2012, 20 years after first joining the Planning Group.

Always hugely popular, Slater-Price established a reputation early on for championing environmental, recreational, and educational projects, as well as being a leading supporter of programs that protect the victims of domestic violence. Like many of the community's early leaders, Pam Slater-Price is proof that it is possible to make a difference. Starting out as just another citizen who felt strongly that the special value of this unique town was worth preserving, she has segued into being one of only five votes for one of the nation's largest county budgets and a supervisor overseeing a district of 600,000 people.

Despite her increased workload, she is still very much in tune with the people who first fired up her enthusiasm for community involvement and in August 2011 was happy to be a key part of the ribbon-cutting ceremony (above) at the new library in Cardiff-by-the-Sea. (Author's collection.)

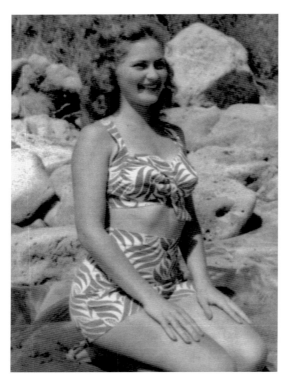

Ida Lou Coley (1927–2005)

Coley was 10 when she and her parents abandoned their failing farm in the Oklahoma Dust Bowl and joined the great migration west, eventually settling in Encinitas. She graduated from San Dieguito High School as class salutatorian in 1945, just as the world was beginning to right itself, and spent the months between school and college having fun on Swami's Beach, where this photograph was taken. (Courtesy of EHS.)

Prolific Writer

History was Coley's great passion. As soon as she retired from her job in occupational therapy, she began writing hundreds of articles for local newspapers and magazines, while diligently recording the oral histories of the old pioneers. With the backing of the Encinitas Historical Society, Coley produced a meticulously researched and illustrated *Downtown Walking Guide*. She is seen here with Connie Lund in 1996 celebrating its launch. (Courtesy of EHS.)

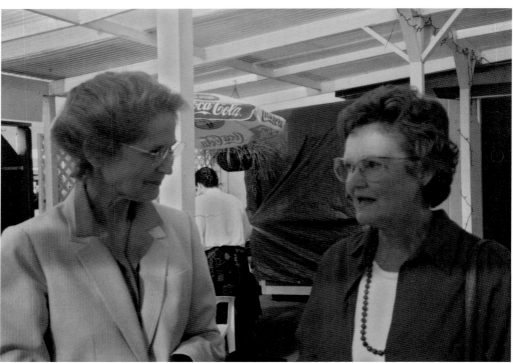

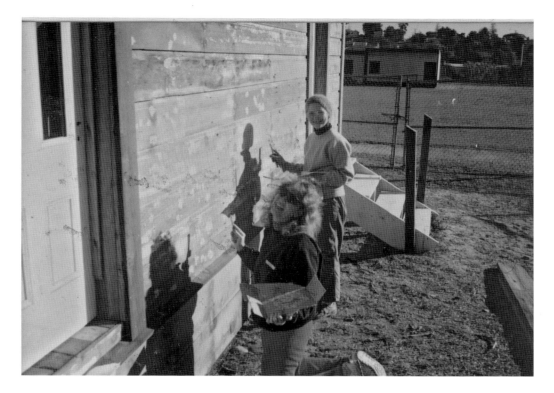

Worker Bee

Coley proved indispensable to the Encinitas Historical Society in their struggle to save the 1883 Schoolhouse and often turned her hand to manual labor in the years between 1983 and 1997 when it was being renovated. This 1995 photograph shows Coley and Lollie McIntire having fun filling holes in the building's redwood siding. (Courtesy of EHS.)

Woman of Merit

Coley's contribution to Encinitas was immeasurable. This 2003 photograph shows her with Fred Harrison (left) and Lloyd O'Connell (right) at the *North County Times'* 10th Annual Women of Merit Awards. The words in the program provide a fitting epitaph for this unforgettable historian, conservationist, and soft-spoken activist: "Without Ida Lou, a significant part of the city's heritage would have been lost forever." (Courtesy of EHS.)

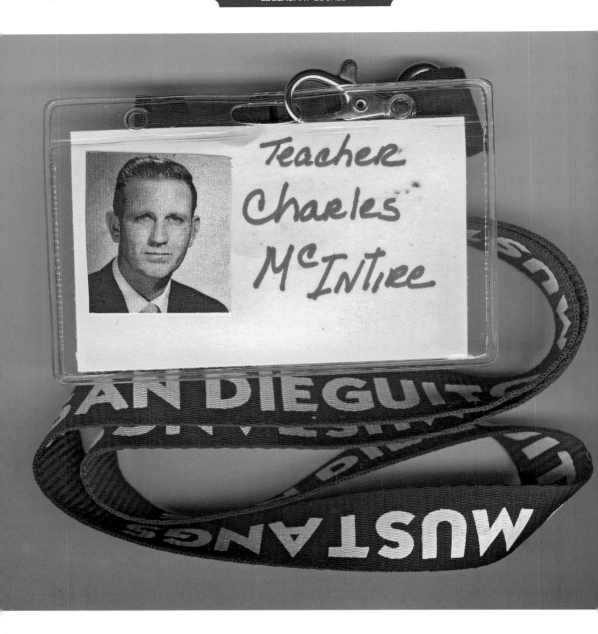

Piglets

When Charlie McIntire started teaching at San Dieguito High School in 1957, he feared he had moved to the sticks. His worst suspicions were realized the day the classroom door burst open and half a dozen squealing piglets darted into the room. When the students started to run, McIntire told them to hold still, predicting that "where there's runaway piglets mama sow won't be far behind." Just before she showed, the agriculture teacher came huffing and puffing into the classroom and McIntire decided then and there that country life was not for him. He planned to hand in his notice but was advised to think about it just a little longer. Which he did: in 1991, 34 years and 12,000 students later, Charlie McIntire retired as one of the school's most popular and respected teachers. (Courtesy of McIntire family.)

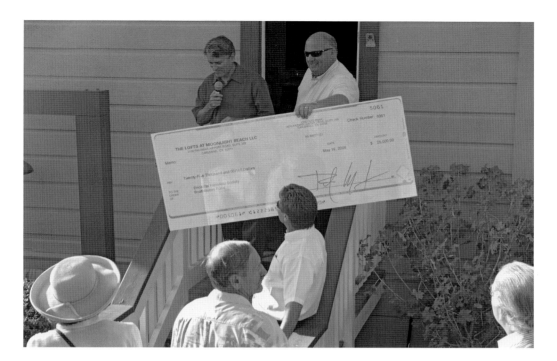

Boathouse Reprieve

For just one day in March 2009, residents and tourists were finally able to stroll around the deck of SS *Moonlight*, one of two boathouses that had been dry docked on Third Street since Miles Kellogg built them in 1928. It was thanks to Peder Norby, founder of the Encinitas Preservation Association, that the boathouses—constructed from floorboards salvaged from an Encinitas dance hall that failed to survive Prohibition—are now deed restricted for preservation in perpetuity. The photographs show Norby with fellow preservationist Tom Cozens (top) on the steps of the Old Schoolhouse receiving a large check from The Lofts at Moonlight Beach toward the boathouses' $1.55 million price tag, and (right) celebrating with the late Maggie Houlihan (left) and Teresa Barth (right) on the day the purchase was officially declared. (Courtesy of Peder Norby.)

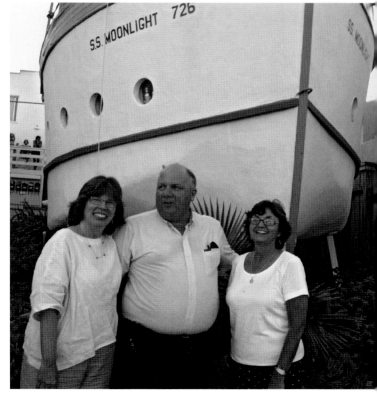

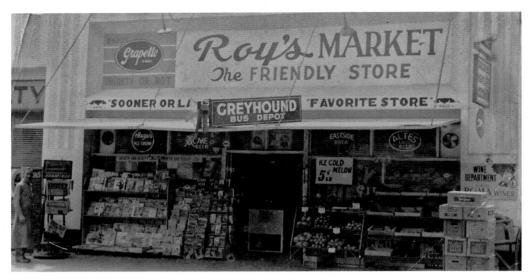

Roy's Market

The banner across the top reads "sooner or later everyone's favorite store." It was also the main stop for the Greyhound bus. Daughter Carolyn remembers hauling 25-pound blocks of ice to meet the heavy demand from the nearby campsite during her elementary school years in the 1950s. Later on, she did the books for her dad, and was paid one percent of the sales. (Courtesy of SDHM.)

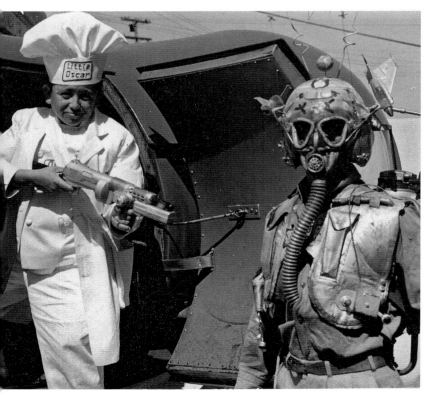

Wiener on Wheels

The first Wienermobile, invented in 1936 by Carl Meyer to publicize his Uncle Oscar's sausages, got swallowed up in the wartime scrap metal drive. Revived in the mid-1940s, these wiener-shaped vehicles often used ex-Munchkins to play Oscar the Chef during their nationwide promotional tours. In this 1950s photograph, Oscar comes face to face with the Man from Mars outside Roy's Market in Leucadia. (Courtesy of SDHM.)

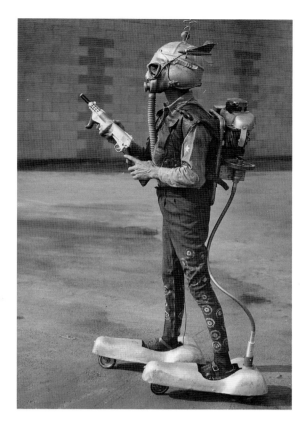

The Man from Mars

Gerard Roy, born in 1912, the 11th of 18 children, left Quebec in the 1930s and found work in downtown Encinitas in the Miller Brothers' grocery store. He quickly earned such a good reputation for honesty and reliability that when he was ready to build his own store friends and family happily lent him the money, knowing that with his strong work ethic Roy would prove a solid investment. Roy's Market, on the corner of Phoebe and Coast Highway 101, known as "the friendly store," was stocked from floor to ceiling with essentials. He even taught himself the butcher's trade. When the US government asked him to build the Leucadia post office on his property, the family's income was guaranteed.

Although Roy never progressed past eighth grade, he was a genius inventor. He had several gadgets patented, including his BAR-B-TORCH, an intricate adaptation of his wife's handheld hair dryer with a long tube attached to a receptacle full of lighter fluid. Roy advertised his novel way of igniting barbecues in *Popular Mechanics* and spent a season at the Del Mar Fair working hard to promote it, but the device never quite caught on.

By far Roy's greatest invention, in the 1950s long before the skateboard put in an appearance, was a set of motorized roller skates. With a gas-driven engine mounted on his back, Roy would zip down the empty I-5 freeway while it was still under construction, reaching astonishing speeds. One day, while hurtling along the aptly named Vulcan Avenue, he was stopped by the local sheriff for exceeding the speed limit—but was never ticketed because the officer was unsure how to write it up.

It was only when a student at Palomar Junior College asked to feature Roy as part of his filmmaking course that the full dress of "Man from Mars" truly evolved. Thereafter, Roy became a much-loved regular in the Encinitas Christmas Parade, and even appeared on the Art Linkletter Show. He passed away in 1988, but the spirit of a self-propelled green-helmeted alien rocketing down historic Highway 101 still lives on. (Courtesy of SDHM.)

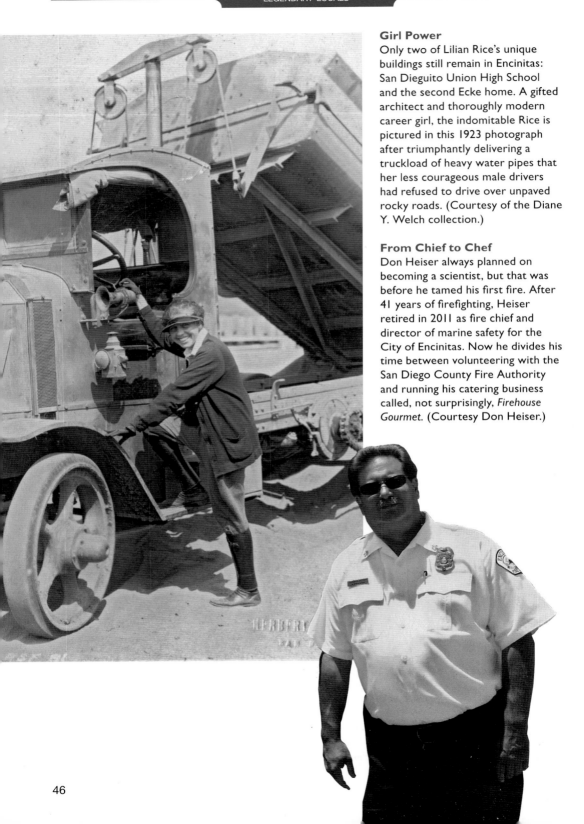

Girl Power

Only two of Lilian Rice's unique buildings still remain in Encinitas: San Dieguito Union High School and the second Ecke home. A gifted architect and thoroughly modern career girl, the indomitable Rice is pictured in this 1923 photograph after triumphantly delivering a truckload of heavy water pipes that her less courageous male drivers had refused to drive over unpaved rocky roads. (Courtesy of the Diane Y. Welch collection.)

From Chief to Chef

Don Heiser always planned on becoming a scientist, but that was before he tamed his first fire. After 41 years of firefighting, Heiser retired in 2011 as fire chief and director of marine safety for the City of Encinitas. Now he divides his time between volunteering with the San Diego County Fire Authority and running his catering business called, not surprisingly, *Firehouse Gourmet.* (Courtesy Don Heiser.)

When Doctors Still Made House Calls

Encinitas was such a small community in 1926 when Dr. and Mrs. Victor Lindsay arrived that his office telephone number was simply 11. Both the doctor and his wife, Mary, a registered nurse, worked around the clock delivering babies and caring for the sick—often taking patients into their own home to ensure they got the best attention. Drunks would be put in a boiling hot bathtub and made to drink endless glasses of lemonade. The only physician for the entire San Dieguito district, Dr. Lindsay not only covered the area from Encinitas all the way out to Del Mar, he also made house calls! The photo shows the Lindsay family around 1932 in their backyard. The baby is Dr. Charles Victor Lindsay Jr., who still lives in that same house. (Courtesy of Elaine Lindsay Harrison.)

Cardiff Matriarch

For her 90th birthday in December 2007, Dorothea Smith's daughter Rosemary Smith KimBal presented her with a book entitled *The First 90 Years*. Containing unforgettably evocative photographs, together with the transcribed results of a hundred different conversations, the book was originally intended to reveal "Dorothea's perspective on Dorothea's life." But it does so much more than that: in compiling the memories of one remarkable woman, her family has also charted the growth of Cardiff.

Dorothea Smith was born in 1917—well before the invention of penicillin or passenger planes and just two days after Woodrow Wilson declared war on Austria-Hungary. She has seen 17 US presidents come and go. When she moved to Cardiff at age 14, there were only 25 families in the village: nobody thought twice about having an ocean-view home. At age 19, she eloped with Milton Smith, her "first real kiss," and put down roots that have deepened through the decades. Today, she lives in the house she designed herself—to the horror of those 1950s neighbors who found its style too futuristic and its windows too bare.

When a call went out in 1949 for bids to build the new Cardiff Elementary School, Smith and her husband, owners of Smith Construction, naturally tendered a bid. Because his four children would be attending the school, Milt purposely underbid the job so that he could be sure the school would be well constructed and safe. The first gilded spade of dirt was turned at the ground breaking ceremony in February 1950 and by September the school was up and running.

Smith has continued to be involved in the school. In 2010, she introduced a project called Edible Landscaping (since renamed Scrumptious Schoolyards) and provided 20 apple and tangerine trees for the students and their parents to plant. She not only wants kids to make the connection between what they eat and where it is grown, but also to understand that establishing roots is important. Long after the children have left Cardiff Elementary, the trees they planted will continue to flourish. (Courtesy of the Smith family.)

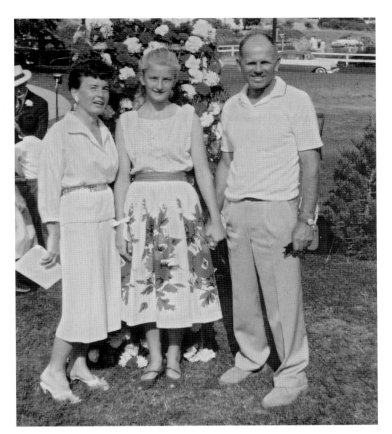

Graduation
Tricia Smith poses with proud parents, Milt and Dorothea, at her sixth grade graduation, June 1958, outside Cardiff Elementary School. Just five years later, Tricia graduated high school in the same year as her older brother David: acing the principal's course in Logic had enabled her to skip 12th grade. (Courtesy of the Smith family.)

All in the Family
A third-generation Smith, Dorothea's granddaughter Catherine Blakespeare is on the board of Edible Landscaping aka Scrumptious Schoolyards and was one of the many volunteers who helped plant apple and tangerine trees on the school campus in December 2010. (Courtesy of the Smith family.)

49

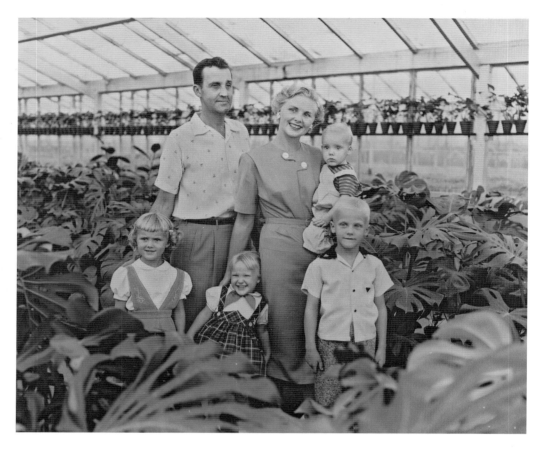

Queen of the Begonias

Evelyn Weidner was just a teenager when she was crowned Queen of the Long Beach Begonia show-and has been recognized as begonia royalty ever since. In 1973, her late husband, Bob, presented her with 25,000 begonia seedlings, and while she was still reeling from the shock, explained that the plan was to nurture them . . . and then get their customers to do their own digging. Surprisingly, it worked. Over the decades, Weidner has established one of the best-loved garden centers in the area with a huge selection of plants. The begonias are still there, but so are fuchsias, violas, poinsettias, and a whole host of others. It is very much a seasonal nursery and almost everything sold there has been grown on the premises. Weidner has a way of sizing up her customers pretty quickly, deciding on their level of gardening proficiency, and advising which plants would best suit their skill level.

But beyond growing a cornucopia of colorful plants, running classes, conducting tours, and finding time to write her regular chatty blog, Weidner has always been deeply involved with the community, as a member of the Rotary Club, the San Dieguito Heritage Museum, and countless other local associations and charities.

She has also won many awards, including first woman Farmer of the Year, San Diego Flower Growers' Person of the Year, and even Mother of Proven Winners (one that her children must surely approve of). Nevertheless, she says that however wonderful awards may be, the most important thing is helping people enjoy and be successful with their plants. Her children, pictured in Bob and Evelyn's Buena Park nursery in 1956, were all raised with an appreciation of their parents' profession, and both daughters, Jan and Mary, can still be found at Weidner's Nursery, happily giving out advice to anyone who needs it. (Courtesy of the Weidner family.)

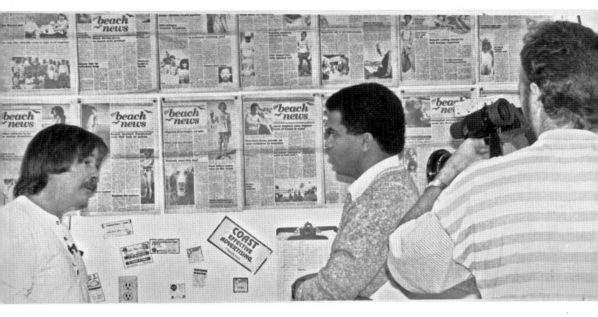

Coast News Group

Jim Kydd, publisher of the Encinitas based *Coast News*, says that the hardest thing he ever did in the long history of his newspaper was clear out his garage. That was in 1987. And when it was done, he bought a couple of $5 desks that had been left out in the rain, painted over the dents, and ran a telephone line out to the garage from his house. On his first day as a newspaper proprietor, he donned a three-piece suit, perched his wing-tipped feet on his desk, and made a few phone calls. Then he changed back into his shorts and got on with the business of building a newspaper that would accurately and intelligently reflect the community's needs. It was tough to begin with, and his credit was maxed to the limit, but he never welshed on a debt.

From such humble beginnings has grown the award-winning Coast News Group, whose two newspapers, the *Coast News* and *Rancho Santa Fe News*, are now distributed to over 700 locations throughout the North County cities of Encinitas, Carlsbad, Del Mar, Solana Beach, Oceanside, and Rancho Santa Fe. Always objective in his approach, Kydd has only once been so strongly opposed to a local issue that he felt compelled to make a stand: in 2005, he ran a full-color advertisement in the *Coast News* publicly opposing the controversial Proposition A, which was seeking to rezone much of the Ecke property on Saxony Road from agricultural to residential. He even offered a $500 prize for the best anti–Prop A poem. Despite knowing the risk he was taking in nailing his colors to the mast, he was convinced it was worth creating the kind of public awareness that would ensure the proposition's demise. His gamble paid off.

This photograph, taken in Kydd's newspaper-lined garage in the fall of 1987, when his fledgling newspaper was still known as the *Beach News*, shows Kydd (left) being interviewed by Joe Oliver for a TV news show. (Courtesy of the Coast News Group.)

Face of the EHS

Lloyd O'Connell was a World War II trainee naval officer at a San Diego social when he first saw Gerry Williams across a crowded room. Seventy years later, he still recalls how it was love at first sight—for both of them. In 1955, they moved their young family to Leucadia, and shortly afterwards, O'Connell became principal of Pacific View and Ocean Knoll Elementary Schools.

A member of the Encinitas/Leucadia Historical Society since its inception in 1980, O'Connell became totally immersed in the society after he retired in 1984. By then, the group's highest priority was to find a new location for the 1883 schoolhouse. Since 1927, it had ceased to be a school and been moved to H Street and Fourth, where it was converted into a residence. Now the developers had come calling and the owner wanted to build condominiums. He offered the schoolhouse to the historical society for $1, but there was long-drawn out dissent in town while various parties argued over its new location. Finally the school board agreed to situate it on the Pacific View property, and a triumphant crowd walked the one-room schoolhouse from H Street to F: not quite the building's original location, but close enough. O'Connell thinks it is probably sited on the old 19th-century outhouse.

As president of the society, O'Connell was responsible for the smooth running of the 1983 move and the building's refurbishment and eventual establishment as headquarters of the Encinitas Historical Society in 1997. However, he is keen to emphasize that the project was successful only because of the considerable time, talent, and energy donated by so many devoted laborers and board members. Since that time, others have been just as dedicated as O'Connell, but he remains the indisputable face of the EHS. As the society's longest-serving president, O'Connell's encyclopedic knowledge—imparted with elegance and humor—has turned him into a walking, talking history book. Which is precisely the role this sprightly octogenarian has played for the last 25 years, on the third Saturday of each month (except August), as he leads a group of spellbound sightseers on one of his famous downtown historical walks. (Courtesy of Lloyd O'Connell.)

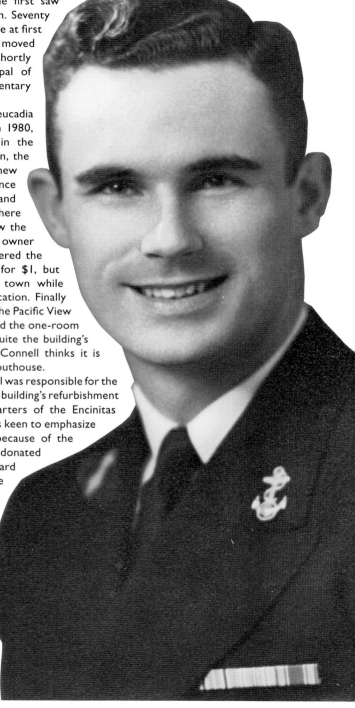

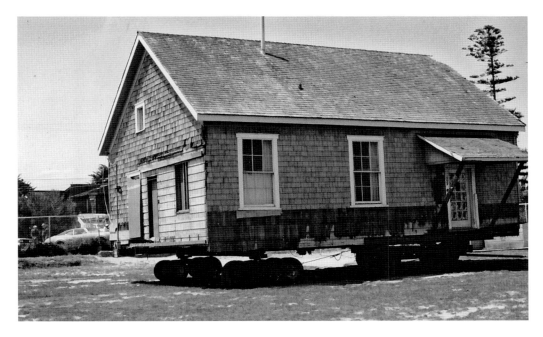

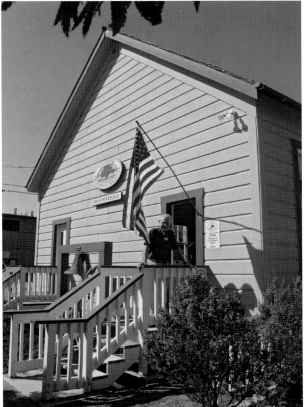

School on Wheels
The one-room schoolhouse served the town's first-through-eighth-graders from 1883 to 1927, when it was deemed no longer viable and moved to H Street to be converted into a residence. In 1983, the Encinitas/Leucadia Historical Society paid just $1 for the hundred-year-old building—and another $2,300 to wheel this grand old lady back home again. (Courtesy of EHS.)

The Schoolhouse Today
After city incorporation, the society dropped Leucadia from its name and became simply the Encinitas Historical Society. From 1983 to 1997, a steady stream of devoted volunteers, under the guidance of then-president Lloyd O'Connell (pictured), worked to restore the schoolhouse to its original character. Today it serves as the headquarters of EHS and is open on Friday and Saturday afternoons. (Author's collection.)

53

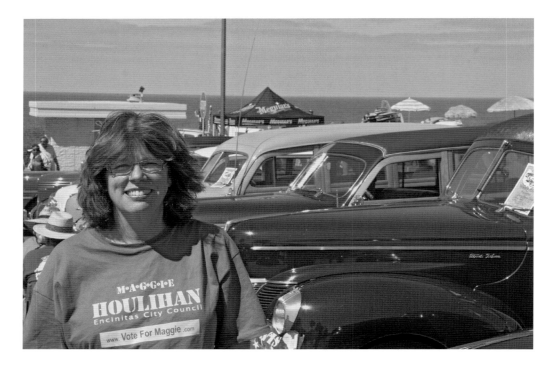

Maggie

Some people in this world are sufficiently legendary to be recognized only by their first names: Oprah, Sting, and Madonna, for example. In Encinitas, you have only to say the name Maggie for everyone to know who you mean. She arrived from Long Beach in 1970 with one dog, two cats, and a toddler, and immediately set about making a life for herself and her son. Famed for her boundless energy, this young busy mother worked several jobs while still finding the time to study at UCSD, graduating summa cum laude with a BA in anthropology. She continued to work at the university for the next 27 years, winning the Employee of the Year Award for 1993/94.

As Encinitas grew, Maggie Houlihan became ever more concerned that it was losing its small-town ambience. Determined to protect the environment and halt runaway development, she ran for, and won, a seat on the city council in 2000. She was returned in 2004 and 2008, with far more votes than any other candidates, each time serving as mayor. Even when her opponents tried to rattle her with underhand tactics, Houlihan always conducted herself with grace and dignity.

A great proponent of government transparency and accountability, Houlihan was instrumental in bringing about the Community Participation Plan, which ensures that residents are kept fully informed of all council and committee agendas, and fought hard for the introduction of televised council meetings.

Houlihan twice beat cancer, with the same energy and passion she brought to all her undertakings, but when it reappeared in the spring of 2011 she chose not to subject herself to more chemotherapy. Even so, she never quit her job as council member, ultimately participating in meetings via telephone. With Houlihan virtually housebound, the center of political debate in Encinitas shifted to her living room, and the stream of friends and colleagues dropping by each day always found themselves embroiled in lively discussion.

Maggie Houlihan died on September 16, 2011, but her legacy lives on—in the environmental issues she so vigorously championed, the animal protection organizations she founded, the many abandoned creatures she housed—from cats to turtles to iguanas—and the government transparency she demanded and achieved. She did it all with such integrity and compassion that she will be forever remembered as one of the true legends of Encinitas. (Courtesy of Ian Thompson.)

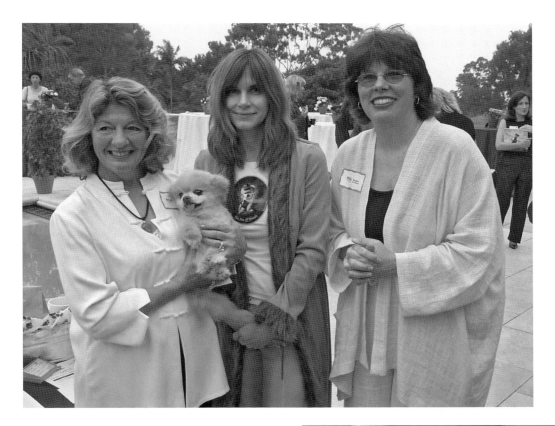

SNAP

Steadfast champion of animal welfare, Maggie Houlihan was instrumental in launching the Spay and Neuter Action Project in 1990, which aims to reduce pet overpopulation through education and low-cost vets. In 1998, she founded the Wee Companions Small Animal Rescue for guinea pigs, rats, and hamsters. Pictured with Houlihan are SNAP co-founder Candy Schumann, the legendary Mr. Winkle, and his owner Lara Jo Regan. (Courtesy of Ian Thompson.)

Sister City

Encinitas has been partnered with Amakusa (formerly Hondo) in the international Sister City program since 1988. During her first term as mayor in 2004, Maggie Houlihan headed up the Encinitas delegation to Japan, further strengthening the two cities' cultural ties by paying her respects at a Buddhist temple (pictured). Her Japanese hosts were delighted when both Houlihan and her husband, Ian Thompson, competed in the Hondo International Triathlon. (Courtesy of Ian Thompson.)

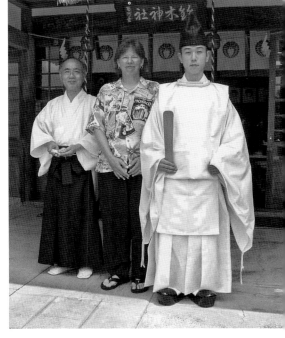

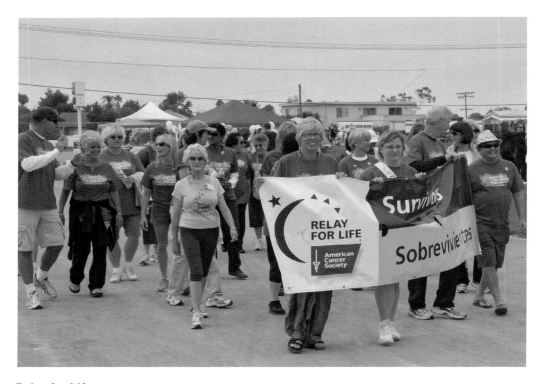

Relay for Life

Houlihan continued to be very involved with cancer research long after her own trademark red hair had grown back gray. This photograph was taken in August 2010 at the fifth annual Relay for Life at San Dieguito Academy. Each member of the 30 relay teams spent 24 hours circumnavigating the track to reinforce the message that cancer never sleeps. (Courtesy of Ian Thompson.)

Continuity

When Ian Thompson married Maggie Houlihan in October 1983, he became her biggest advocate. He continues to be just that, knowing that what his late wife would want more than anything is for the people of Encinitas to fulfill her legacy and engage more in local politics. As she so often remarked: democracy is not a spectator sport. (Courtesy of Ian Thompson.)

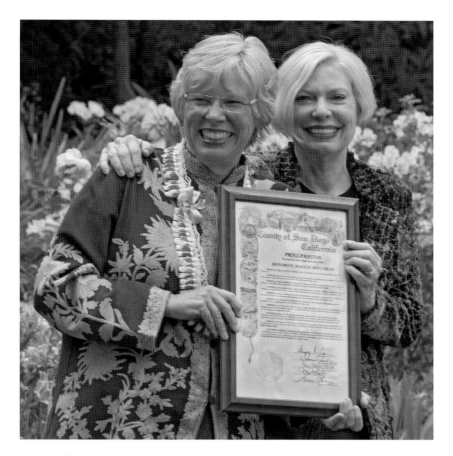

Celebration of Life

In May 2011, after learning the outcome of her latest medical tests, Maggie Houlihan called Julian Duval, CEO of the San Diego Botanic Gardens, rejoicing that she had "more than weeks to live"—and asked him to stage her Celebration of Life while she was still well enough to enjoy it. At the end of the party, she told the crowd, "I feel very, very, very blessed. I've had a rich life, a full life." The proclamation presented by county superintendent Pam Slater-Price (pictured) is reproduced, in part, below:

WHEREAS, Maggie Houlihan is a former mayor of Encinitas; and...

WHEREAS, Maggie Houlihan is a phenomenal woman who radiates compassion for people, as well as animals, and no matter the hurdles, is determined to fight for what she believes in; and...

WHEREAS, Maggie Houlihan personifies the meaning of a true public servant; she has a well-respected reputation among her constituents and community for her involvement in community affairs; and...

WHEREAS, her willingness to work tirelessly with groups, even when there is no political gain or personal upside, has been made evident on many occasions; and...

WHEREAS, the County of San Diego is committed to recognizing and honoring those individuals who are dedicated to the best ideals of public service; NOWTHEREFORE, BE IT PROCLAIMED by Chairwoman Pam Slater-Price and all members of the San Diego County Board of Supervisors that they commend MAGGIE HOULIHAN for many years of outstanding service, leadership, and commitment to area residents, and do hereby declare this to be "MAGGIE HOULIHAN DAY" throughout San Diego County. (Courtesy of Dorell Sackett.)

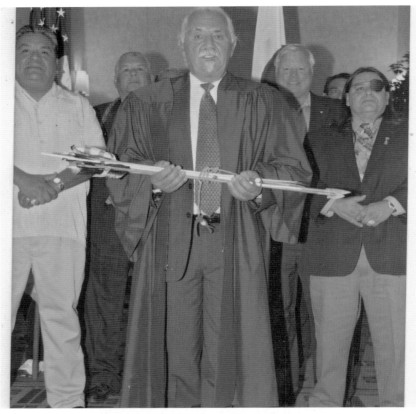

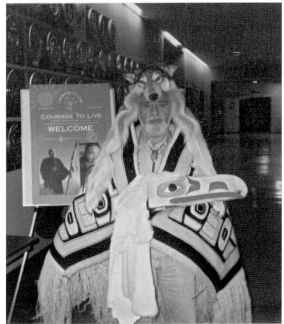

Tribal Judge (LEFT)
Tony Brandenburg, a former Superior Court commissioner and currently chief judge of the Intertribal Court of Southern California, was a kid of 18 when he stuck a pin in a map, jumped on a Greyhound bus, and arrived in Encinitas. Since then he has become increasingly prominent in the community. As a member of the Rotary Club of Encinitas, Judge Brandenburg once instituted a novel holiday gift idea for the Hopi women of Arizona when he asked his fellow Rotarians to place a few unwanted hotel toiletries and coins in gently used purses. At the reservation, they happily distributed the bags in a modified version of the traditional Hopi basket dance, as a gift from the people of Encinitas. Having worked in Indian country for over 25 years, Judge Brandenburg says he is aware of the deprivations within Hopi life and intuitively felt the need to fill the gap. The photos show him being sworn in as tribal judge in 2006 (top) and (below) in Native American dress. (Courtesy of Judge Brandenburg.)

How Many Pennies Make a Mile?
Irene Kratzer knows. As a founding member of the Friends of Cardiff-by-the-Sea Library and twice its president, Kratzer played a significant part in its Mile of Pennies fundraiser. She also serves on the board of the Cardiff Chamber of Commerce, has a regular column in the *Coast News*, and was grand marshal of the 2009 Encinitas Holiday Parade. Furthermore, she is the only person in her community to be awarded a prize for "infectious enthusiasm." She even took on the mighty Rand McNally—and won. Dismayed to find her town's name missing from their 1989 road atlas, Kratzer got 500 schoolchildren to write to the publishers persuading them to reinstate Cardiff. It duly reappeared in the 1990 edition. And the answer to the question? There are 16 pennies in one foot. And 84,480 in a mile. (Author's collection.)

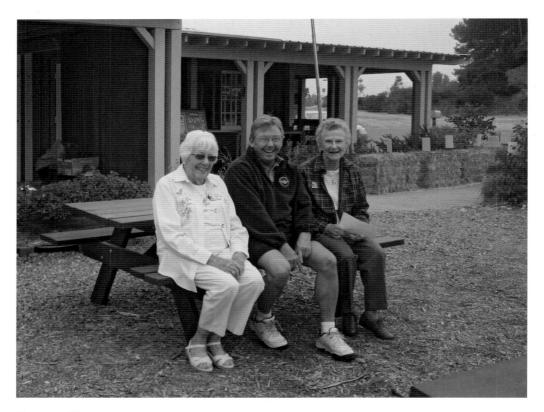

Treasure Trove

The San Dieguito Heritage Museum (SDHM) was founded in 1988 by Encinitas residents with deep community roots and an abiding attachment to the area. Bettie Grice Wolfe (left) can trace her family back to the town's earliest arrivals—her great-grandfather was E.G. Hammond, the man who constructed so many of the town's buildings, including his own house, Sunset Ranch. The property was later sold to Paul Ecke Sr. and has since become part of the Encinitas Ranch Golf Course. Whenever Bettie drives by the pond at the edge of the course, she is immediately transported back 80 years to the long hot summers she and her siblings spent swimming in that same pool of cool water on grandpa's ranch.

Jan Grice (right) is one of the founding members of SDHM, and as Bettie's sister-in-law, belongs to one of the town's original pioneer families. Her late husband Bob, son of Jane Hammond Grice, was known throughout town as a "go-to guy" and shortly before his death at age 87 was honored with the role of grand marshal in the 2006 Encinitas Parade. Jan Grice is the primary contact for the accessions and collections for the museum in the Greater San Dieguito Area and catalogs all the events of note within the museum and community. Jay Clark (center), who volunteers as docent, photo archivist, and Native American School Program instructor, often jokes that Jan Grice "literally knows where all the bodies are buried." Her extensive knowledge of the area is so essential to SDHM that Clark wishes he could find a way to download her entire memory and keep it on file.

The San Dieguito Heritage Museum provides an interactive resource not only for the many schoolchildren who come on regular visits, but for anyone wanting to delve deeper into the past, from the earliest archaeological artifacts through pioneering legends to skateboards and surfboards. The constantly changing exhibits ensure that there is always something new to discover. Occupying over an acre on Quail Botanical Gardens Drive, the site is often the setting for community events and regularly plays host to the October Lima Bean Festival. (Author's collection.)

CHAPTER THREE

Carrying the Torch

If the early pioneers set the tone, it was the next generation that built upon all they had achieved, turning a cluster of farms and homesteads into a vibrant and independent city. Sons and daughters move away of course—Encinitas real estate prices prove how easy it is for a town to be a victim of its own success—but many still remain and continue the good work their parents and grandparents set in motion.

Wendy Haskett, who documented much of Encinitas history in the *North County Times*, is remembered with great affection, not only for her regular newspapers column, *Backward Glances*, but also through her son Gordy, who spends his mornings baking delicious sweetmeats at Gordy's Bakery, and his afternoons coaching the high school running team. In local politics, Bill Arballo passes on the mantle of public service to his daughter, Councilwoman Teresa Barth.

Paul Ecke Sr. was known throughout Encinitas as an astute businessman but also a generous and kindly person willing to help his neighbors. His son Paul Jr.'s donation of 20 ocean-view acres to the people of Encinitas made the magnificent Magdalena Ecke Family YMCA possible, and now his grandchildren, Lizbeth and Paul Ecke III, continue the family tradition by giving time and resources to a variety of Encinitas organizations.

In Cardiff-by-the-Sea, a salty sea dog, aka "Captain Book," dressed as an extravagantly attired pirate, boards the *Good Ship Literacy*, and drops off books to children who might not otherwise have access to them, while his octogenarian friend Larry Marquardt lovingly hand carves each treasure chest before the trusty crew of Kiwanis Club volunteers fills them with donated books.

Now that the turbulent years are over—no more fields to hoe, no freeways to reroute—there is time for the luxury of giving back, be it delivering meals on wheels, working as an occasional docent, or traveling further afield, as Rotarian Niels Lund does, helping Cambodian mothers set up their own small businesses.

And as ever, when help is needed with medical bills or simply to sustain a heroic little boy dealing with chemo, the wagons still gather in a circle.

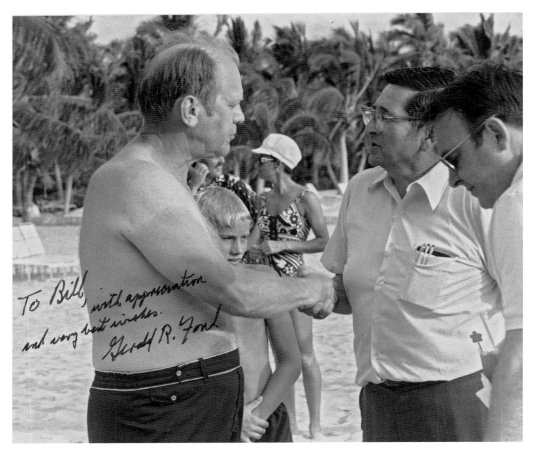

To Bill, with appreciation and very best wishes. Gerald R. Ford

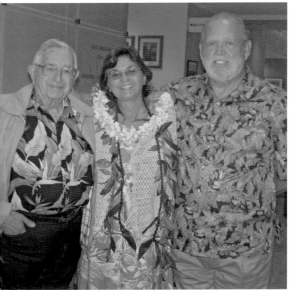

Family Tradition

When Bill Arballo, former mayor of Del Mar, started writing for the *Coast News* in 1998, he was only planning the occasional article, but his "Eye on the Coast" column proved so popular, it became a regular feature over the next 10 years. The photo (top) shows Arballo interviewing Gerald Ford at Mauna Kea Beach, Hawaii, shortly before President Nixon's 1974 resignation.

With a father so deeply dedicated to community service, it was no surprise when Teresa Barth won a seat on the Encinitas City Council. Elected for her honesty and insistence on government transparency, she is someone who talks the talk and walks the walk. And when not walking, Barth, a sincere environmentalist, can be found cycling around town. The photo shows her in 2004 with Arballo and husband Don at city hall after being sworn in for her first term of office. (Courtesy Teresa Arballo Barth.)

Backward Glances

Author Wendy Haskett was a walking, talking time machine when it came to local history. Perhaps it was her English upbringing, but she was genuinely fascinated by the people she met every day and the wealth of stories they had to tell—the hard times they endured and their unexpected successes. She was much loved by everyone who met her and had the knack of transporting her readers back in time with the huge assortment of memories and amusing anecdotes she had somehow managed to winkle out of her subjects. Around 100 of her "Backward Glances" columns, originally published in the *North County Times,* have appeared in three books of the same name. Haskett was working on a fourth volume when she passed away in 2006. She often staged lively presentations for school groups at the San Dieguito Heritage Museum (SDHM) where she had been a member since its very earliest days. Since Haskett's passing, the museum has honored her memory through their annual Wendy Haskett Essay Contest for third graders. Her books are still available at SDHM and local libraries.

Haskett's days were so consumed with writing that when sons Gordy and Craig arrived home hungry from school, she would point to the kitchen and tell them to fix something for themselves. Thus began Gordy's lifelong love affair with baking. Now he has his own funky café, *Gordy's Bakery,* just a short jog from the Y, where he personally creates and bakes every cake, pie, and muffin. The café's walls are adorned with original art by Scrojo, aka his brother Craig. More of Scrojo's work can be found at Belly Up in Solana Beach. Wendy Haskett was always known around town for her stylish clothes and eye-catching headgear—and this photograph is no exception. It shows her with parents Bill and Cordelia Rimington, and sons Gordy (top) and Craig, on the same day the first man walked on the moon. (Courtesy of Haskett family.)

SDA Cross Country Running

When not filling Gordy's Bakery with the delicious smell of fresh-baked goodies, Gordy Haskett can be found coaching the cross country running team at San Dieguito Academy. The best runners each year are presented with an original poster from Gordy's artist brother, Scrojo. The photograph, taken in October 2010, shows Haskett, far left, with the SDA School Cross Country Team and assistant coach, Dori Patterson. Justin Conn, at the far right, is an assistant coach and English teacher at SDA. (Courtesy of Gordy Haskett.)

Growing Passion

Nan Sterman, author of *California Gardeners Guide volume II*, practices what she preaches. Her Olivenhain backyard is an exercise in sustainable landscaping, and her family eats healthily from the fruits and vegetables they grow. A regular columnist on the *San Diego Union Tribune*, Sterman also writes for *Sunset Magazine, Organic Gardening*, and *Pacific Horticulture* and is a regular guest on KPBS. Her bright and beautiful website, Plant Soup Inc, is aimed at the experienced gardener just as much as the nervous first-timer. In fact, she so enjoys helping people transform their backyards that she regularly turns her own into a giant outdoor classroom, showing small groups how to start vegetables from seed and diligently following up on their progress. Teacher, consultant, tour group leader and blogger, Nan cheerfully admits, "if it's got to do with plants, I do it". (Author's collection.)

Mosaic Mon

On October 1, 2011, the City of Encinitas celebrated its 25th birthday as an incorporated city. Terry Michael Weaver (pictured), also known as "Mosaic Mon," was responsible for the intricate mosaic depicting the city seal. More of his delicate work can be found in E Street Café in downtown Encinitas. (Author's collection.)

Babies by the Sea

Picture an OB/GYN who gives you his cell phone number, waives his fee when you find yourself between insurance companies, and even drives you to the hospital all the while coaching you through contractions. Robert Biter, dubbed by one experienced midwife as "an OB in midwife's clothing," is all these things, and more: that rare creature who listens to his patients and supports them in their own educated choices. As technology in the delivery room grows ever more interventionist, the much-loved Dr. Biter is increasingly respected for his willingness to buck this trend, staying close to his patients, however lengthy their labor, as he safely sees a new life into the world. "Imagine," he says, "the power of giving every person a loving, nonjudgmental, and empowered beginning." (Photograph by Dawn Tacker for eosphoto.com ©2011.)

Moonlight Beach Christmas Tree
Possibly the only tree in Encinitas to have its own address, the legendary 83-foot pine on Fourth and C Streets has been lit up every Christmas since 1994. Luis Ortiz and friends hang up the hundreds of lights and the Downtown Encinitas MainStreet Association (DEMA) pays for the electricity. Ortiz started the tradition to honor all his friends from the old Moonlight Beach days who have since passed on. (Courtesy of Luis Ortiz.)

Seasons Greetings
Elders, Young Ones, & in Between
1994

peace on earth

David vs. Goliath
It was news to Scott Chatfield when he read that the Encinitas 760 telephone area code was changing yet again. So he started a website encouraging like-minded people to e-mail elected officials—one of whom, Assemblyman Martin Garrick, made the issue a priority. After a packed and emotional hearing, the California Public Utilities Commission did a complete 180. A small thing perhaps, but affirmation that grassroots ideas can still catch fire and effect real change within a community. (Courtesy of Scott Chatfield)

Sheriff Volunteer

Not surprisingly, Sanford "Sandy" Shapiro was voted Volunteer of the Year by RSVP (Retired & Senior Volunteer Program) in 2011. After 40 years of problem solving with a number of large international companies, Shapiro and his wife Michaele moved to Encinitas in 2000. Since then, he has become well known around town for his commitment to several local organizations, the most important being his role as an Encinitas parks and recreation commissioner. He also works with the sheriff's Senior Volunteers, a job that involves patrolling residential neighborhoods, schoolyards, and shopping centers. Since 9/11 security checks of strategic sites have also been added. And for those homebound elderly participants of the YANA (You Are Not Alone) program, it is always reassuring to receive a friendly knock on the door from Sandy. (Courtesy of Sandy Shapiro.)

The *Good Ship Literacy*
With around 5,000 books on board, Captain Book's eye-catching ex–ambulance is en route to another classroom. Since initiating the literacy project during his 2000/2001 term as president of the Kiwanis Club of Greater Encinitas, Dr. Morris Pike, the man behind the make up, has given away more than 53,000 books to preschool-through-primary-grade children in intricately decorated wooden chests. (Courtesy of Jan Jackson)

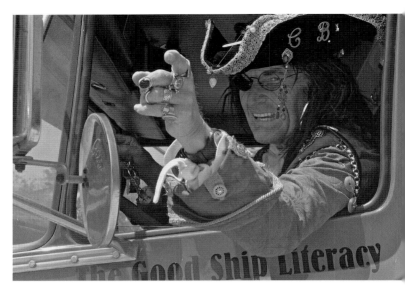

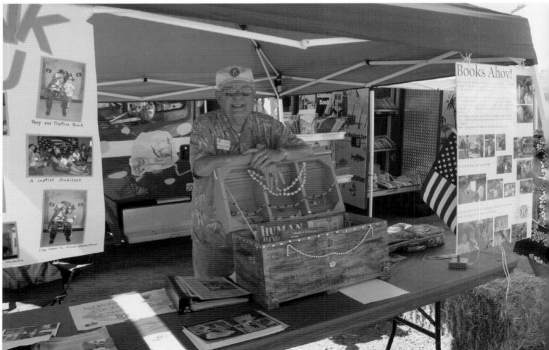

Larry Marquardt
When Larry and Cathy Marquardt's children were young, their home was always the place that "every kid knew they could go to," according to Teresa Barth. Formerly a scoutmaster, and member of the Cardiff business-owner's association and chamber of commerce, Larry Marquardt now spends hours constructing wooden treasure chests to hold the many books donated each year through the Greater Encinitas Kiwanis Literacy Program. (Courtesy of Jan Jackson.)

Captain Book

Dr. Morris Pike believes that the more books there are in a home, the more likely it is that a child will succeed in school. Recalling his own struggles as a young reader, this retired theater professor regularly dresses in his best pirate finery and visits classrooms, libraries and hospitals around San Diego County, giving his special performances and handing out books to children who might not otherwise have access to them.

The Captain and his motley crew comprise members of the Kiwanis Club of Greater Encinitas who volunteer their time and talent to ensure that the Good Ship Literacy not only stays afloat but also continues to charter new territory. Many of the volunteers collect and sort the books; others take on the arduous but rewarding task of building and decorating the wooden treasure chests. They all share the same goal: to change the world one child at a time. And if it takes a swashbuckling pirate arrayed in counterfeit diamonds, rusty cutlass, and jangling chains to show that books are the greatest treasure of all, then they know they have succeeded.

Singing his finest songs, this merry pirate inspires his young audience with tall tales of fabulous ships and the brave sailors who guide them home. As soon as each child has promised to "read, read, read," Captain Book writes another name in his Magic Code Book. Recently, after steering the Good Ship Literacy into another safe harbor, the Captain received a letter from one of his young converts. While thanking him for introducing him to the world of piracy on the high seas, the boy said that the greatest thing Captain Book had taught him was that knowledge, once learned, remains for all time, and is worth far more than gold or jewels. (Courtesy of Jan Jackson.)

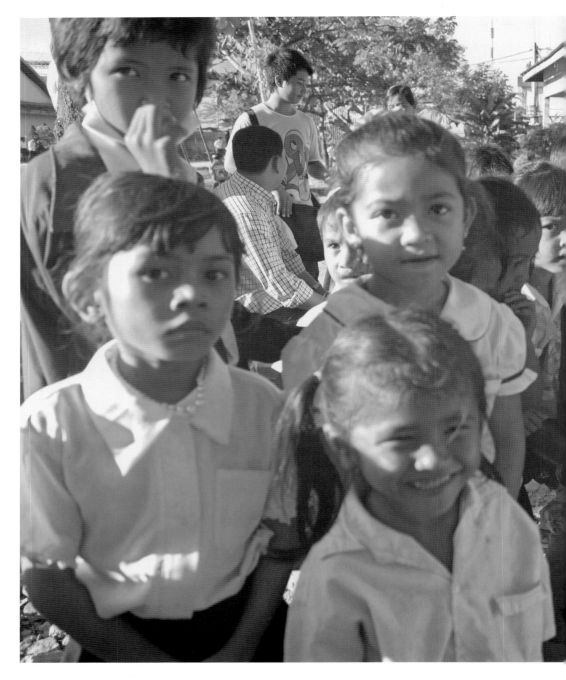

Class Act
In 2010, Niels Lund, executive director of Class-ACT, spent three weeks visiting schools in Cambodia. From that experience grew his desire to help the young women of the country's capital, Phnom Penh. Lund and his colleagues launched Microloans for Mothers by giving each woman a $100 business loan. Once these are repaid, with the interest going directly to the school, the young entrepreneurs are eligible

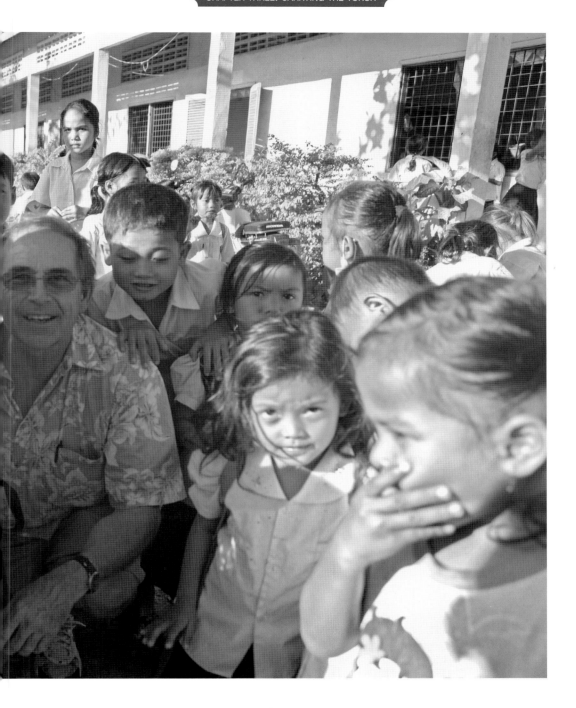

for a further $150. The program has been so effective that it now includes neighboring villages. Much of its success is due to the generosity of the people of Encinitas and Lund himself, whose background as a children's performing arts coordinator makes him ideally suited to the task. (Photograph by Jessica Wawrzyniak.)

Tree of Life

Julian Duval, president and CEO of the San Diego Botanic Gardens (formerly Quail Gardens), has overseen some enormous changes since arriving in 1995. Perhaps the most stunning of all is the Hamilton Children's Garden, opened in June 2009 with a generous donation from local philanthropist Frances Hamilton White.

Duval believes strongly that children should connect with the earth, get their hands dirty, and learn where their food comes from. When he heard that the oldest tree in Leucadia had died and was about to be cut down, he asked to have it placed in one of the children's areas so that they could use it as a natural climbing frame. He says that outdoor play is important in a child's maturation process. A few years ago, when a sizeable piece of property became available for an innovative children's garden, Duval was keen to have a giant tree house as its centerpiece. But there was just one problem with creating the kind of amazing tree house he had in mind: there were no trees. He says they could have added a "big fake tree" but decided that would have been as incongruous as a zoo with a big fake elephant.

And so Duval and his team brought in a designer who began by constructing an artificial tree along the lines of an Indian banyan, with multiple trunks adding to its authenticity. Since his Midwestern childhood, Duval has been fascinated by epiphytes —plants that grow above the ground using others for support—so they added a huge variety as camouflage, and as the ferns and orchids and succulents gradually took hold, the manmade tree underneath became a living breathing entity supporting a most wondrous tree house. While this magical musical garden is primarily aimed at children, it is an amazing horticultural experience for anyone, whatever their age. The fairytale tree that emerged, and continues to take shape, would have the most cynical adult begging to be a kid again. Go take a look. (Author's collection.)

Small Schools and Socrates

The Grauer School's philosophy is simple—to encourage students to become resourceful and compassionate individuals, based on the Socratic model, where the teacher presumes the natural intelligence of the learner. The school was founded in 1991 by Dr. Stuart Grauer, who also went on to found the Association of Small College Preparatory Schools in 2011. That same year, the school held its 20th senior graduation, with Grauer (left) delivering the keynote address.

For a school so enthusiastically a part of the Small Schools Movement, its classrooms are surprisingly large: the whole world in fact. As part of their humanitarian ethos, the students have visited every continent except Antarctica on cultural projects. Grauer also met the principal of the Hand in Hand School in Jerusalem (bottom) with its mix of Arab and Israeli students. (Courtesy of Stuart Grauer.)

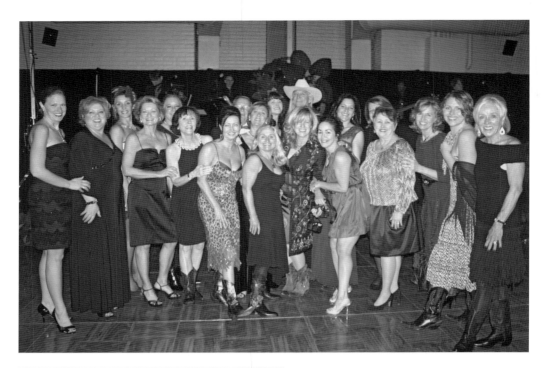

Boots & Ballgowns

The Ecke family foundation allocates a large percentage of its annual giving to many local organizations, including the Community Resource Center, Paul Ecke Central School, and Scripps Hospital. Lizbeth Ecke, pictured center at the 2010 YMCA Boots & Ballgowns gala, believes that everyone should invest in their community. "We're raising our children here and we want it to continue to be a great place to live." (Courtesy of the Ecke family.)

The Planner

It takes a special sort of person to relish 19 years of unpaid work, but Lester Bagg says that heading up the City Planning Commission without a stipend afforded him the luxury of a conscience. An architect by profession, Bagg's judicious input was hugely influential in shaping modern Encinitas. Now retired, he can look across Encinitas from his leafy backyard with the satisfaction of knowing he helped create such a vibrant community. (Author's collection.)

Faithful Dylan

Not all heroes have two feet. Some have four. Julie Kirtland was out walking her golden retriever, Dylan, in March 2010, when she suddenly collapsed. Nobody saw her go down, so Dylan stayed close by her side, barking at passersby to attract their attention. Finally two people came to her rescue. By the time the EMS and fire department had arrived and diagnosed sudden cardiac arrest, the two Good Samaritans had gotten Kirtland breathing again. Neither Dylan nor Kirtland had ID, so she spent her first 24 hours in an induced coma as Jane Doe.

Dylan is still a legend on the street where he lives: the loyal dog who alerted two strangers to perform CPR on his mistress. But he did more than just save his owner's life that day. The episode also had a remarkable effect on the two anonymous passersby who responded: the man subsequently became a leader at his son's scout troop where he ensures that CPR skills are a high priority; the woman, a maternity nurse who had previously been having doubts about her career choice, realized that she really could make a difference. Both strangers disappeared as soon as the EMS and firemen took over, but after weeks of detective work Kirtland discovered their identities and Michael Blakeley and Julie Joslin, along with the firemen who responded to their call, received commendations for heroism from Encinitas City Council. (Author's collection.)

Service Above Self

The Rotary Club's motto, "service above self", was what first attracted Carolyn Cope to the organization. In fact, these three words perfectly encapsulate all that Cope is and believes in. A true Encinitas native, Cope still lives on the property where she was born. In 1982, she moved to Japan while her then-husband fulfilled his Navy obligation as a flight surgeon, and then to Houston, where she opened her Rising Sun Gallery, selling Japanese art and antiques. But her heart and soul always remained in Encinitas. So when her father, Gerard Eugene Roy, became terminally ill in 1988, she felt that her giant inner rubber band had stretched far enough and it was time to come home.

Vowing to get reconnected and involved in her recently incorporated city, Cope immediately joined the new Sister City Committee, at the time twinned with Hondo in Japan, now known as Amakusa. She also jumped right into the San Dieguito Heritage Museum and the Encinitas Historical Society and has remained an active member of both for almost 25 years. She is also an essential part of the Downtown Encinitas MainStreet Association (DEMA) and has twice been voted "Volunteer of the Year."

In 1990, shortly after the birth of her third child, Cope started building her present home on the site of her parents' old one, and moved in the following April. By the fall of 2009, with her children grown and mostly gone, she had turned her stylish and breezy downtown home into the McNeill Guest House (pictured).

If that were not enough, Cope also spends afternoons taking care of Coast Highway Traders on Highway 101, a funky store full of amazing finds. She learned her people skills from her dad, proprietor of Roy's Market ("the friendly store"). And when not looking after customers, making sure her houseguests are comfortable, or fulfilling her volunteer obligations with DEMA, EHS, and SDHM, she collects elementary school-age political refugees from San Dieguito Academy and drives them into San Diego for tutoring.

The years Cope spent away from Encinitas are forgotten, and the gap closes as she continues to serve the community she grew up in, mixing with the people she has known since kindergarten—those same friends who affectionately voted her "class clown" when they all graduated in 1968. (Author's collection.)

The Petticoat Junction Girls

Hugh Martin was renowned for his musicals, such as *Meet Me in St. Louis*, but he also produced less famous works, like "The Encinitas Song," which he co-wrote with local historian Ida Lou Coley. Carolyn Cope and Betsy O'Neill conveyed its sentiment perfectly in their unique rendition during the city's 25th birthday celebrations in October 2011. (Author's collection.)

Celebrate Good Times

On October 1, 2011, the City of Encinitas celebrated the 25th anniversary of the incorporation of Leucadia, Olivenhain, Cardiff-by-the-Sea, Old Encinitas, and New Encinitas. In this photograph (left to right) Councilwoman Kristin Gaspar, Councilwoman Teresa Barth, Deputy Mayor Jerome Stocks and Mayor James Bond receive a commemorative proclamation from State Assemblyman Martin Garrick. (Author's collection.)

V.G. Donuts

A beloved landmark for over 40 years, V.G. Donut & Bakery, across from Cardiff Beach, has been providing old-fashioned doughnuts, cakes, and cookies through three generations of the Mettee family. It is rare in a seaside town to find a place where the locals still love to hang out, but even though it is eminently popular, there is no need to worry that the selection will be diminished by the time you reach the counter. Doughnuts are baked, right where you can see them being twisted, pummeled, and sprinkled, at 4:00 a.m. and 4:00 p.m. Pictured next to Jerry Mettee is Conor Paris, who first visited V.G. at one day old with his mother, father, and grandparents on his way home from the delivery ward. His father, if he remembers correctly, had a chocolate with coconut. (Author's collection.)

Mighty Max (RIGHT)

A legend in his own precious lifetime, Max Spartacus Kleckner is living proof of how a community can unite when one of its members is under siege. Max was just four when, in July 2008, he was diagnosed with Stage IV rhabdomyosarcoma, a rare form of cancer found in just 300 children worldwide each year. The tumor was inoperable because of its proximity to the brain and optic nerve and had already metastasized into Max's bone marrow.

Max had a passion for superheroes, so it made sense for his parents, Mark and Natalie, to explain his treatment in terms of good guys and bad. They told Max that the doctors would install a semi-permanent "superhero port" in his chest to give all the superhero cells easy access to the enemy. After chemotherapy in San Diego, Max went to Houston to begin an eight-week course of proton radiation therapy. But three weeks into treatment Max encountered another enemy—Hurricane Ike—and treatment was suspended. Battle-weary, but still triumphant, Max and his parents returned to their Cardiff home to find their neighbors had wrapped every tree, gate, fence, and pole in their front yard in gold ribbons.

Our superhero had a good year until the cancer relapsed. This is when Cardiff-by-the-Sea went into overdrive: neighbors, restaurants, and other local businesses staged benefits—including volleyball tournaments, street parties, auctions, and raffles—to mop up the costs not covered by insurance. In a time when so many people have their own concerns, one small boy was still able to unite hundreds of people in a show of financial, spiritual, and emotional aid. Mark Kleckner calls it a very bright spot in a very dark place.

It may take a village to raise a child, but it also takes a village to heal one. (Photograph by Aaron Feldman/True Photography.)

Making an Entrance

Jinx Ecke, former wife of Paul Ecke Jr., has a reputation not only for being involved in a huge number of deserving charities, but also for enjoying the ride along the way. One that Ecke particularly enjoyed happened in 1990, the year she chaired the annual Ritz "Rendezvous in the Zoo" charity gala, making her spectacular entrance on an elephant's trunk. (Courtesy of the Ecke family.)

Commander Bill

Tucked away on West F Street, American Legion Post 416 has been at the core of Encinitas so long it sometimes gets overlooked. But this unobtrusive building provides a welcome environment for veterans and, on certain nights, the rest of the community. Bill Hicks, lifelong Encinitas resident and veteran of two Vietnam tours in the late 1960s, has been its commander since 2006. (Courtesy of Cris Hicks.)

CHAPTER FOUR

The Board Culture

Skateboards, surfboards, and snowboards. At first this Southern California city may not seem the obvious place for snowboarding, but the drive from the Encinitas beaches to Big Bear Mountain is less than 150 miles—which means you can peel off your wetsuit after a morning surfing Moonlight Beach and be lacing up your snowboarding boots just three hours later.

One of the area's favorite surf spots—featured in the Beach Boys' 1963 hit "Surfin' USA"—is Swami's Beach, named after the Self-Realization Fellowship Retreat on Historic Highway 101. And while Encinitas is famous for its legendary surfers, there is also that infamous one: the Cardiff Kook, which has slowly morphed from a figure of fun into a beloved Encinitas icon.

For those who still enjoy the thrill of soaring through the air, but prefer to land on something a little more solid, the Magdalena Ecke Family YMCA has one of the best skate parks in the country, designed to fit all levels, from the mini land with smaller ramps and gradual transitions to a 120-foot vert that many will remember from the 2003 X-Games.

Curiously, skateboarding has always been much more of a male-dominated sport, but Cara Beth Burnside is beginning to change all that. Frustrated by the barriers put up against women skaters, she started taking her skateboard along to every snowboarding event she competed in, until people realized that she was exceptionally talented at both and eventually accepted her for the brilliant and fearless skater that she is.

Further inland, there is a sports park named after Leo Mullen, one of the original founders of the first Little League in North County and a coach for almost 20 years. But these are not the only reasons the park bears his name. More than anything, Mullen just wanted the kids to have fun and thought it important enough to convey the message that Little League was for the children, not their parents. Anyone able to get that across deserves to have a park named in his honor.

Surfer Crossing

When graphic artist Cris Hicks suddenly had to brake on Highway 101 while a boy holding a long board wandered into traffic, she decided that instead of honking her horn she would design a notice warning drivers to watch for surfers.

Initial feedback from the authorities was mixed: they worried about erecting a sign that appeared to condone jaywalkers, but when Hicks drew their attention to similar signs showing illegal immigrants dashing across I-5, her case was won. Local businesses enthusiastically embraced the idea and were happy to fund such a funky (and potentially life-saving) initiative. The 10 iconic signs featuring both male and female surfers soon became desirable treasure, but scavengers were discouraged after workmen slathered copious amounts of slippery grease onto the metal poles. So far, only one mother has had the audacity to complain about the resultant grease smeared down her child's shirt. (Author's collection.)

Green Surfer
With 12 career World Tour victories, Rob Machado is indisputably one of the world's greatest surfers. But more than that, this local hero has always been a tireless supporter of environmental education. Much loved and feted in his hometown, Machado was an integral part of Cardiff's festivities when it celebrated its first hundred years in July 2011. (Author's collection.)

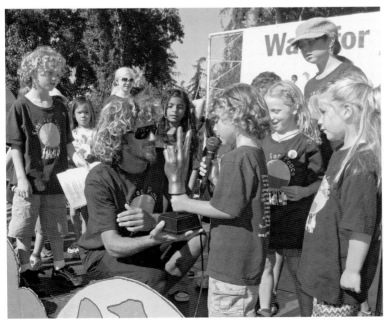

Peace Hero
In 2008, Machado received the Peace Hero award at the third annual Kids for Peace Festival in San Diego, while further afield this surf legend was happy to take part in an Indonesian well-digging project. Since its launch in 2004, the Rob Machado Foundation has also helped Cardiff schools fund several green initiatives, including the development of a hands-on curriculum to learn about oil spills and landfills. (Courtesy of Wehtahnah Tucker.)

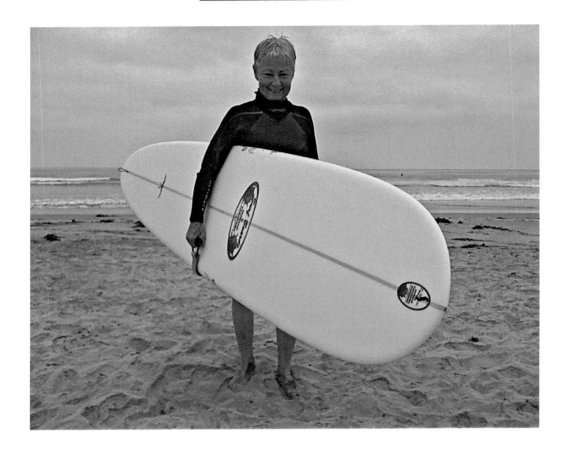

Enjoy the Journey (ABOVE AND ABOVE RIGHT)
Linda Benson started surfing at Moonlight Beach when she was 11 years old, waiting for the boys to lose a board so that she could paddle it back out to them. By the age of 15, she had become the youngest contestant ever to enter the International Championship at Makaha and went on to become the first woman to ride Waimea, when she borrowed a board from the shortest guy she could find (Benson only just tops five feet) and caught a couple of waves.

In a sport that 50 years ago was almost totally dominated by men, Benson won the first US Championship at Huntington Beach, in 1959, and held onto it through much of the 1960s, setting the record for the number of wins by a woman at that event. During the next decade, she won over 20 first place surfing titles. One thing that women surfers have over the men—they make prettier surfing doubles, and Benson was much in demand for movies like the *Beach Party* films and *Gidget Goes Hawaiian*. In 2009, she finally got to play herself, in *The Women and the Waves*.

Benson says that when she first got into the water, she was always "chasing after the guys." Aware that even in the 21st century many women still preferred to be taught in an all-female environment, Benson started her popular surfHER school in 2003, only winding it down four years later when she wanted to concentrate full-time on her latest project: designing the kind of gadget that would make it easier to transport unwieldy surfboards without incurring the sort of hip damage her own doctor was beginning to warn her about. She is pictured above demonstrating her newly launched "Rail Grabber." An immediate hit, Benson's unique invention has made it even more possible for this pioneering female surfer to live up to her lifelong motto: "Enjoy the journey, love the ride." (Courtesy of Linda Benson.)

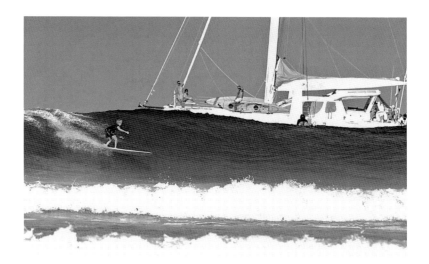

California Surfing Museum

It was at Jane Schmauss's former Cardiff restaurant, George's, that the idea for a surfing museum was first born. Soon outgrowing its location, the fledgling museum moved to Moonlight Plaza in Encinitas for one year, followed by another two in Pacific Beach, and finally Oceanside, where it eventually settled into its stunning home at Pier View Way. Despite its itinerant existence, the museum has grown from strength to strength since its inception in 1986, and now contains one of the best collections of surfing and skating memorabilia in the area. This 1987 photograph shows Schmauss, one of CSM's founders and co-author of Arcadia's *Surfing in San Diego*, holding artist Darcy Baker's brilliantly airbrushed surfboard. (Photograph by John Nelson, Courtesy of California Surf Museum.)

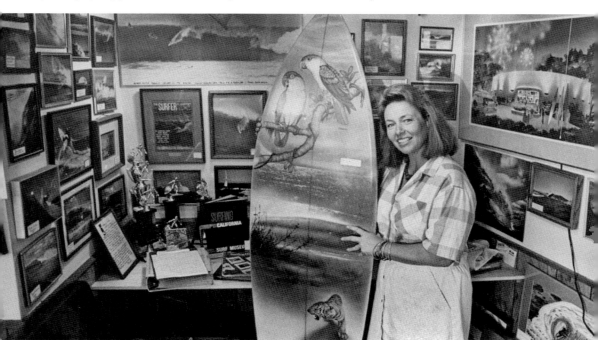

Phoenix Rising

Anyone who can perform a 900—an impossibly difficult two-and-a-half-revolution aerial spin on a skateboard ramp—would have no trouble turning his life around once or twice. Tony Hawk, one of Encinitas' most famous and beloved residents, was apparently hyperactive as a child and while his parents knew he was bright, they despaired of ever finding a good outlet for all his pent up energy. Enter a beat-up skateboard, donated by his brother, which changed his life irrevocably.

By the age of 12, Hawk was winning amateur contests throughout California. He turned pro at 14, and by his 16th birthday was generally regarded as the best competitive skateboarder in the world. Life went from good to better: by age 25, he had entered and won 73 out of 103 pro contests, going on to be crowned vertical skating's world champion 12 years in a row. But just as rapidly as he had soared, the Hawk found himself abruptly grounded when skateboarding suffered a dip in popularity in the early 1990s. Never one to give in, Hawk spent the decade successfully revitalizing his career until he realized it was time to give back.

In 2002, he established the Tony Hawk Foundation, which helps finance public skate parks in low-income areas. Hawk feels strongly that a mere 3,000 skate parks scattered throughout the United States are not nearly enough to support its 9.3 million skateboarders, and points out that over 90 percent of deaths involving skateboards occur *outside* designated parks. "I cannot stress enough," he says, "the importance of skate parks in high-risk areas—they offer kids a safe place to go and something to do that gives them a sense of self-esteem they may never find anywhere else. Once communities get their first park, they almost always build more because they see the enduring positive effects they have on kids."

To date, the foundation has donated over $3.4 million to more than 450 skate park projects nationwide. (Photograph by J. Grant Brittain.)

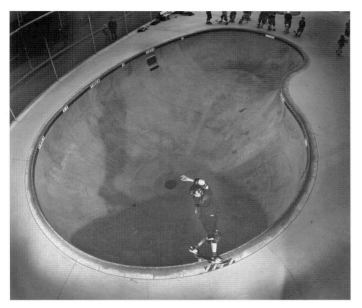

Hurricanes and Torches

Wearing his nine gold, three silver, and two bronze medals earned at the Summer X Games between 1995 and 2002, Tony Hawk (photo at left) holds the Olympic torch he was honored to carry through San Diego's Gaslamp Quarter. The photograph on the left shows Hawk performing "the hurricane" at the Magdalena Ecke Family YMCA, where he also designed the vert ramp. (Photographs by J. Grant Brittain.)

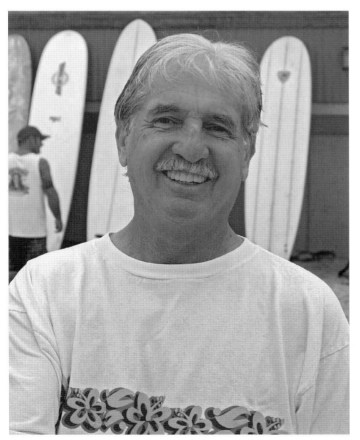

The Surfer's Photographer

It is almost impossible to flip through a surfing magazine and not come across Tom Keck's name. Having covered most of the California surfing competitions for over five decades, as well as Hawaii and Costa Rica, this former North County lifeguard has been published in the *Los Angeles Times*, the *Union Tribune, Time Magazine,* and a variety of surfer publications throughout Japan, France, Australia, and the UK. Keck also spent 20 years working for KGTV-10 ABC in San Diego as a photojournalist, and in 1993, was inducted into the Surfing Hall of Fame for photography. (Courtesy of Tom Keck collection.)

Hansen Surfboards

Don Hansen's life was changed irrevocably the day he watched a surfing movie in his college frat house. As soon as he graduated, Hansen traded the snows of South Dakota for the California waves and took off on his first ever surfboard. Completing his two-year Army stint in 1961, Hansen headed for Hawaii, where he started shaping and selling Hansen Surfboards from a small shack, returning to the mainland the following year to open a shop in Cardiff-by-the-Sea. The photograph, dated 1963, shows him in the surf workshop of his first mainland store. By 1967, business was so good, Hansen Surfboards had moved to larger premises, in Encinitas, where his store —somewhat enlarged—still stands. The late 1960s saw a revolution in surfboard manufacturing: long boards were being replaced by short ones, which meant that many stores were going under now that surfers could build and shape their own boards. But Don Hansen knew that in San Diego, with the Pacific ahead of you and Big Bear behind, it's possible to surf and ski in the same day, so he expanded his business to include skiing, snowboarding, skateboarding, and body boarding.

Fifty years after its modest beginnings in a Hawaiian beach shack, Hansen's has grown to be San Diego's largest surf shop with more than 16,000 square feet of retail space. And yet it still has the feel of a friendly local store. Perhaps this is because it is so rooted in the community, with its sponsorship of local organizations, like Encinitas Little League, Cardiff Soccer, YMCA Skate Park, and Swami's Surfing Association, as well as its wider philanthropic contribution. One such is Hansen's involvement in the Soles4Souls campaign, which offers a 10 percent discount on new shoes for every old pair handed into the store. Hansen's donated 6,000 pounds of shoes in 2010. The store has also been running its Goods for Grades program for 25 years. The scheme rewards undergraduates from all across the United States by handing out merchandise vouchers in exchange for good report cards. This country must be bursting with bright students—in June 2011, Hansen Surfboards handed out vouchers for more than $20,000! (Courtesy of Tom Keck collection.)

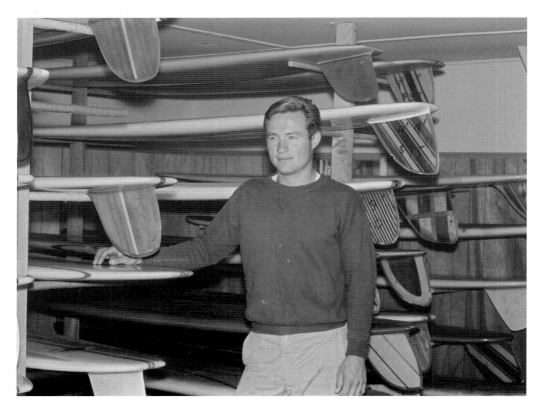

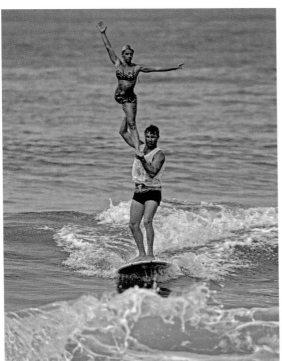

Tandem Surfing
Taken by renowned surfing photographer Tom Keck, this action shot shows Don Hansen and his partner Diane Bolton competing in the 1967 National Tandem Championships at Huntington Beach, California. Needless to say, they beat the competition. (Courtesy of Tom Keck collection.)

Proving Grounds
When Mike Doyle (right) worked for Don Hansen in his Cardiff store during the 1960s, they would start each day surfing at "the proving grounds"—so called because those who wanted a job with Hansen first had to prove themselves at this particular shore break. Doyle was fully vindicated in 1965 when *Surfer Magazine* voted him "the most competitive and versatile surfer in the world today." (Courtesy of Tom Keck collection.)

Submariner Surfer

Octogenarian Fred Ashley is one of the area's legendary surfers and lifeguards. In fact, Ashley loved surfing so much as a young man that rather than risk being drafted into the wrong arm of the military, he volunteered for the Navy hoping to get sent to Pearl Harbor as a submariner. Fortunately for Ashley the gamble paid off and he spent his time either riding the waves or submerged well below them, in his words "shadowing Ruskies." This recent photograph shows Ashley, an accomplished artist as well as surfer, with the self-portrait he painted back in his surfing days holding one of his highly decorated surfboards. It is currently on show in the skating and surfing exhibit at the San Dieguito Heritage Museum. (Photograph by Gerry Kirk.)

Bing Sings
Ashley's maternal grandfather, Scottish immigrant Fred Coutts, or "the Gen" as he was commonly called, rose to be one of the country's best hunting dog trainers. The Gen (seated) often accompanied his neighbor Bing Crosby on quail hunting expeditions on the Bumann property as this 1937 photograph shows. Young Fred enjoyed Bing's company, finding him easygoing and generous. (Courtesy of the Bumann family.)

The Gen
Back when Los Batiquitos Lagoon was still wild country, Fred "the Gen" Coutts enjoyed hunting there with his dogs. Grandson Fred Ashley, an accomplished illustrator and graduate of the Chouinard Art Institute, made this pen and ink drawing of the Gen some time during the mid-1940s, following one of his grandfather's Batiquitos hunting trips. (Author's collection.)

93

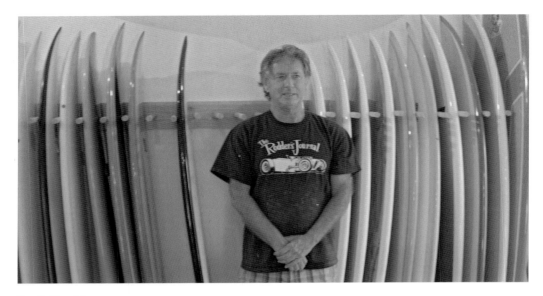

Surfy Surfy's
Peter St Pierre and friends began restoring surfboards in the empty spaces of La Paloma Theatre in the 1960s. Such was their popularity that by 1979 they had moved to larger premises out of town. More than 30 years later, *Moonlight Glassing* is still run by those same four surfers who founded the factory. You can find their superbly hand-glassed boards at Surfy Surfy Surf Shop, the Leucadia store co-owned by St. Pierre's son, J-P, on Highway 101. (Author's collection.)

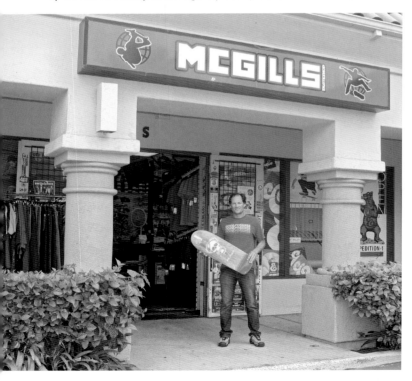

The McTwist
To the skateboarding world, Mike McGill is famous for his 1984 invention of the amazing McTwist, an inverted 540-degree mute grabbed aerial. But to the locals, McGill is simply the guy who owns the friendliest skate store in town. In fact, his employees like to call McGill's the Cheers of skate shops: the place where everybody knows your name. (Author's collection.)

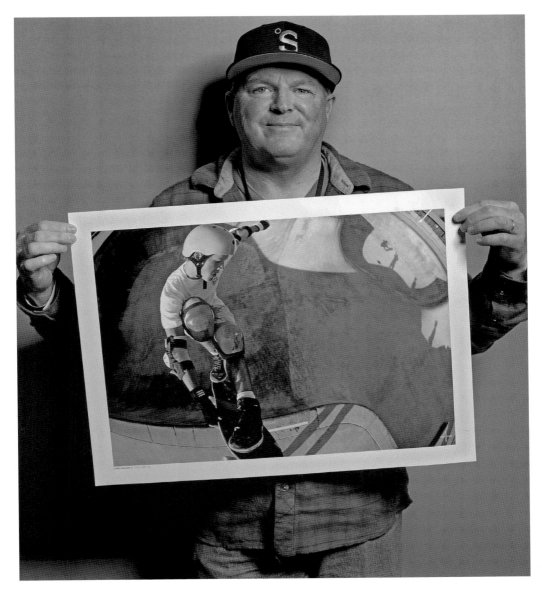

Skateboard Photographer

Look closely at the action shot in Grant Brittain's hands, especially those amazing shadows on the right. This photograph of Cardiff resident Chris Miller is one of Brittain's most famous, shot with a pole camera in 1986. Another one that got widespread recognition featured skater Andy MacDonald and appeared on a US postage stamp.

As soon as he graduated high school, Brittain moved from landlocked Fallbrook to Cardiff so that he could concentrate on surfing. In 1983, he and two friends, Larry Balma and Peggy Cozens, started *Transworld Skateboarding Magazine*. He went on to co-found *The Skateboard Mag* in 2004. Brittain's work has been featured worldwide throughout the media including ESPN, *Sports Illustrated*, and *Men's Journal*. He is also a regular contributor to photographic exhibitions, including his own AIGA solo show in San Diego. (Photograph by KC Alfred.)

Woman in a Man's World
In 1995 Cara-Beth (CB) Burnside was ranked the second best snowboarder in the world. But she is also arguably the most influential woman in skateboarding today. She has a gold medal from the Summer X Games, her own character in Tony Hawk's RIDE video game and a VANS signature shoe. Pictured here at the Magdalena Ecke Family YMCA, Burnside is living proof that extreme sports are more than just boys and their toys. (Photograph by J. Grant Brittain.)

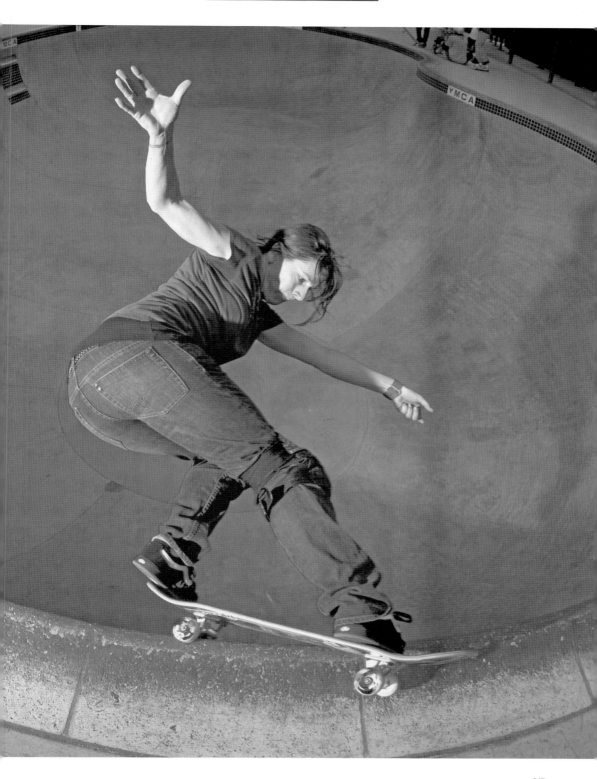

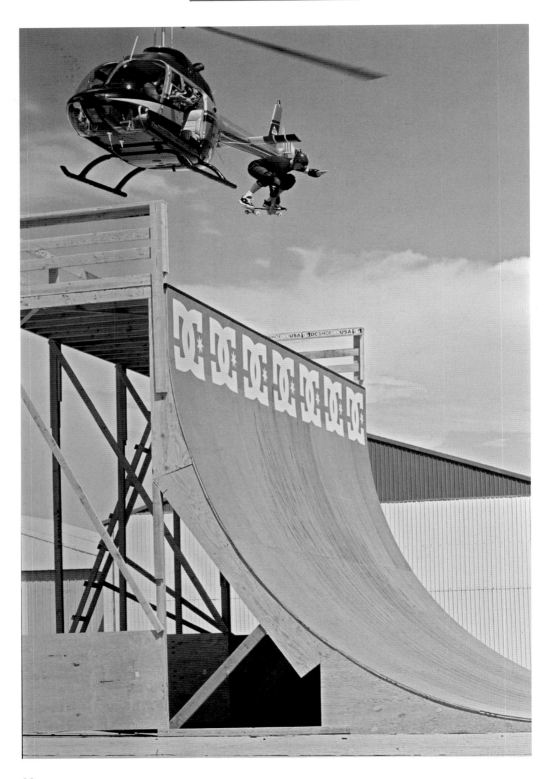

Way to Go (LEFT)
Olivenhain resident Danny Way broke the world record for highest air at 16 feet 6 inches in 1997 and immediately afterwards bomb-dropped out of a hovering helicopter onto the same gigantic ramp. Way began skating at age six when he lied about his age to get into Del Mar Skate Ranch. By the mid-1980s, he was earning the respect of professional skaters and even beat Tony Hawk in a skater version of "horse." But his greatest challenge came in 2005 when he became the first person to successfully jump the Great Wall of China on a non-motorized vehicle, soaring across a 60-foot gap, and spinning a backside-360 over the wall. (Photograph by J. Grant Brittain.)

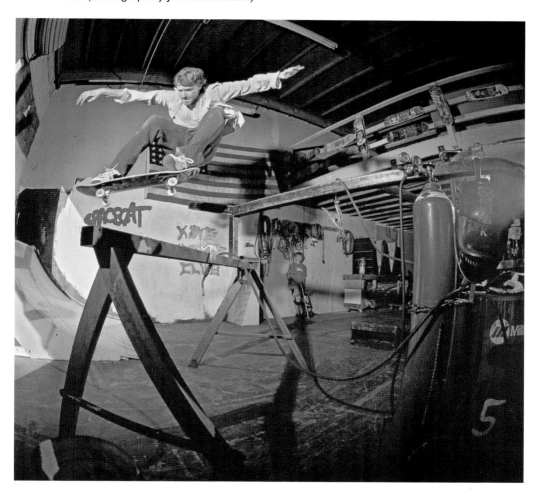

Built to Shred
The first three seasons of Fuel TV's *Build to Shred*, hosted by professional skateboarder Jeff King (shown here performing an Ollie), have often featured King's Encinitas house, renamed "Shred Ranch," as he turned junkyard oddments and discarded detritus into obstacle courses, half-pipes, ramps, and rails. But in late 2011, King's landlord announced that developers were planning to knock down his Requeza Street house and replace it with nine single-family homes. Knowing it was about to be demolished anyway, King used the opportunity to trash his house himself—with the help of fellow skaters Tony Hawk, Bucky Lasek, and Bob Burnquist. The event was recorded for the program's Season Four opener. (Photograph by J. Grant Brittain.)

The Cardiff Kook

From the moment Matthew Antichevich's *Magic Carpet Ride* was unveiled in 2007, the sculpture has been lambasted by the surfing community for being unrealistic and effeminate.

Originally intended to portray a female surfer—which apparently required twice the amount of bronze—the statue had to be redesigned when funds ran low. The result, located along Historic Highway 101, ended up looking like a surfer wannabe or, in surfer-speak, a "kook."

Loved and despised in equal measure, the kook is regularly dressed up to reflect the latest happenings. One Valentine's Day, residents awoke to find the kook transformed into Cupid. Anyone following the trajectory of his arrow across the train tracks to Carpentier Park would have found it embedded in the heart of the statue of the late Wayne Holden, a beloved son of Cardiff. (Photograph by Fred Caldwell.)

They Paved Paradise

Bert's Plumbing has been an Encinitas institution since the late Bert Long (pictured) and his son Doug opened for business in 1974. Around the same time, they began their long history of sponsoring one of the San Dieguito Bobby Sox teams, and their practice field on Devonshire was even renamed Bert Long Lutheran Field in his honor. But it has long disappeared, paved over and turned into a parking lot.

Bert's Squirts

Inspired by their plumbing sponsors, the softball team chose to call themselves "Bert's Squirts." This photograph, with Bert Long at center, shows the team proudly displaying their new logo. Like his father, Doug Long has always been a dedicated volunteer within the community, and in recognition, DEMA recently presented him with two of its most prestigious awards: Volunteer of the Decade and the Ida Lou Coley award. (Courtesy of the Long family.)

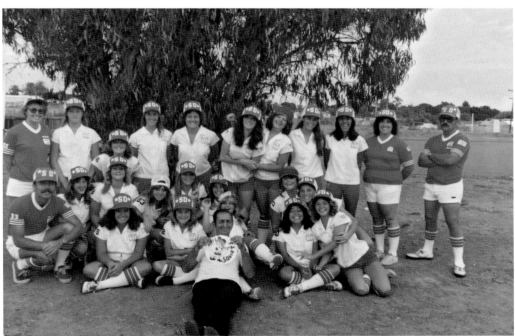

Jurassic Park
The Cardiff Kook has been Vincent van Gogh, Kate Middleton, Osama bin Laden, and even a tasty snack for Jaws, but to date its best reincarnation came in August 2011 when the boy on the plinth found himself about to be spirited away clutched in the talons of a giant pterodactyl. The City of Encinitas objects to this form of public art, complaining that it spends thousands of dollars annually dismantling the statue's unsolicited embellishments, fixing its twisted and broken back, and installing ever more lights to deter the midnight decorators... but the fun continues. (Author's collection.)

Little League Founding Father

As one of the founders of the San Dieguito Little League in 1959, Leo Mullen covered all the bases, from coach to umpire to president and district representative. He always insisted that Little League was for the benefit of kids, not their parents, and is immortalized with the sports park on Via Cantebria that bears his name. (Author's collection.)

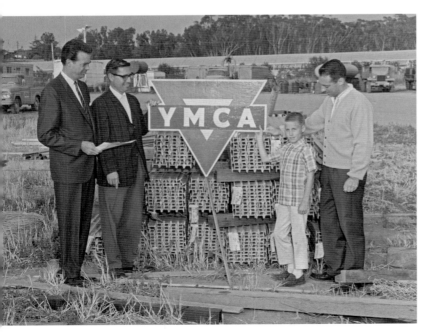

Ground Breaking

The old Encinitas Y was totally revamped after the Ecke family donated 20 acres and renamed it the Magdalena Ecke Family YMCA in honor of the family matriarch. Recognized as one of the best Y's in the country, it was also the first, west of the Mississippi, to be named after a woman. This photograph taken at the 1968 groundbreaking ceremony shows (from left to right) Bob Watrous, Paul Ecke Jr., Paul Ecke III, and Rollie Ayers. (Courtesy of the Ecke Family.)

CHAPTER FIVE

Arts Alive

For the last 10 years, spring in Encinitas has been heralded by hand-painted banners hanging from light poles along Historic Highway 101. Advertised as "the most amazing free art event of the New World," this public display of original works of art stretches from Cardiff to Leucadia. After brightening the main thoroughfare for two months, the banners are auctioned off to benefit local artists and community programs.

According to the city's arts administrator, the chakras out in the ocean make Encinitas a vortex of creativity. And it is true. Its laid back funky beach culture has always attracted artists and writers, actors and musicians, even before the downtown picture house existed. Built in 1928, just as silent movies were giving way to talkies, La Paloma Theater still remains a big part of community life. Twice a year, poets from all over the country perform at a poetry slam to standing-room-only crowds. Both the annual Arts Alive Banner Display and Poetry Slam are initiatives of the Encinitas 101 Artists' Colony, a collective that allows local artists in all genres to perform and showcase their work.

The funky, vibrant "one mile of talent" Art Walk held along Leucadia's streets each year also showcases a diverse range of local art, while the library on Cornish Drive provides a constant platform for the music and art that is so integral to Encinitas. Local artists regularly stage art shows, such as the highly original "Artists by Artists", brainchild of Mary Fleener, who selected from a wide range of business owners, teachers, models, and musicians, all artists in their own right, to paint and be portrayed by one another, with striking results.

But perhaps the most notorious piece of public art in recent years has been the *Surfing Madonna*, a 10-foot-square mosaic that mysteriously appeared one morning on the wall of a train trestle. Taking on legendary status within days of materializing, the mosaic depicting Our Lady of Guadeloupe on a surfboard brings together all the elements of Encinitas and underscores its identity as a surf city full of talented artists.

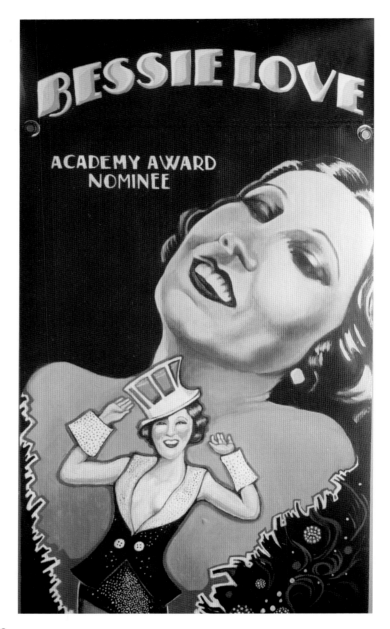

Bessie Love

Whenever possible, movie star Bessie Love would escape Hollywood for her Encinitas home. The compound comprised four cottages, but apparently only one "person" was allowed to reside in the cottage with the claw foot tub: Olaf, the Irish wolfhound. In 1929, Love made her triumphant transition from silent movies to talkies when she starred in MGM's first musical, *Broadway Melody*. She was nominated for best actress, but sadly the Oscar that year went to . . . Mary Pickford.

This portrait of Bessie Love was painted by local artist Dody Crawford as part of the 2011 Arts Alive Banner Program and generously donated to the Encinitas Historical Society by two of the city's best-known supporters of the arts, Dave and Margo Oakley. (Courtesy of EHS.)

Movers and Shakers
This photograph shows another of Dody Crawford's eye-catching works of art. The poster was designed in 1986 to mark 20 years of Encinitas cityhood and, in a parody of a certain illustrious album cover, features such Encinitas legends as Paul Ecke III, Danny Salzhandler, Peder Norby, and Fred Caldwell—all names that are still closely connected to the community's enrichment. (Courtesy of Dody Crawford.)

History and Heritage
Mac Hartley spent all his working life as a university lecturer, producing a number of books along the way, but none so glossy or painstakingly researched as his beautiful *Encinitas History and Heritage*. He is pictured here in October 2000, presenting a copy to Mayor Yasuda of Hondo (now Amakusa) in Japan, sister city of Encinitas. (Courtesy of EHS.)

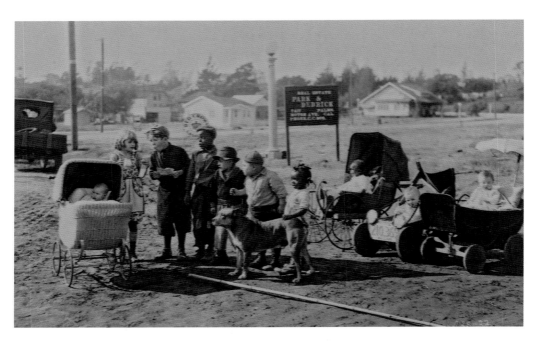

Little Rascal

Lola Larson's new husband Bobby accuses her of nepotism: he is, of course, perfectly correct. Larson's movie producer uncle, Hal Roach, signed her up for *The Little Rascals* when she was still in her pram (left), but she is quick to remind Bobby that while nepotism got her through the door, it was sheer talent that kept her there. Over the next decade, she continued to act in *Little Rascals* and got to meet such luminaries as Oliver Hardy (right), whom she still remembers as "a perfect Southern Gentleman."

Larson's connection with Encinitas began in 1928, when she came to live with her grandparents. She often returned to Hollywood and remembers one eventful night when she asked a handsome man in a bar if he really was Frank Sinatra. When Sinatra wordlessly slapped Larson's behind, her outraged husband was all set to defend her honor. But Larson had different ideas and told him she planned never to shower again. (Courtesy of Lola Larson.)

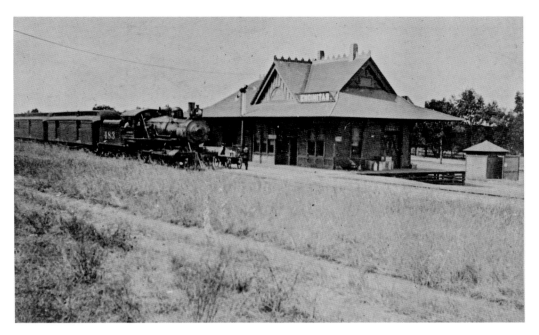

Still Legal

The Oxford English Dictionary defines a pannikin as "a cup or vessel used for drinking," but residents and tourists have long known that the Pannikin is one of the coolest cafés along Highway 101. Old-timers still recognize it as the 1887 Encinitas train station (pictured in the early 1900s) that was sold in 1970 for $1 by the Santa Fe Railway. Now the restored building boasts a rotating array of art on its ancient walls and in its grounds during events like the Leucadia Artwalk. Shawn Holder, who with his wife has owned the Pannikin Coffee and Tea since 1997, wears a t-shirt (pictured) that screams "Still Legal!", reminding us that we can thank the perpetrators of the 1773 Boston Tea Party for keeping our favorite beverages tax exempt. (Courtesy EHS (top) and the author.)

The Dreyfuss Initiative

Olivenhain resident and Academy Award winner (*The Goodbye Girl, 1977*) Richard Dreyfuss says that "this country is a miracle and the whole world knows it—except Americans, because we don't teach it." The solution is his Dreyfuss Initiative, a program calling for a cross-curricular study of civics in schools, incorporating history, reason, logic, and critical thinking. He is pictured here taking his message to the Grauer School in Encinitas. (Courtesy of Stuart Grauer.)

Marion Ross

According to her Cardiff neighbors, everyone's favorite *Happy Days* mom is the best kind of celebrity: she happily takes part in local functions and if, say, the library needs a little help, quietly opens her checkbook. In July 2011, Ross, looking far younger than her 82 years, took on a new role—that of grand marshal perched on a 1936 Auburn speedster during Cardiff's Centennial Celebrations. (Author's collection.)

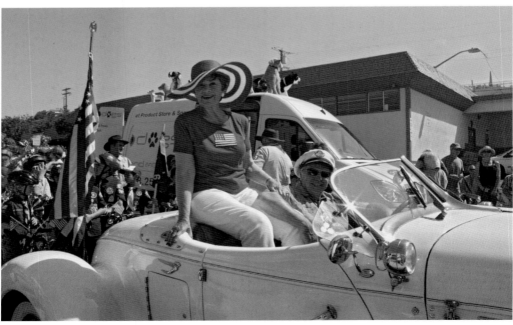

Blonde in White Convertible

Do you know me?
I am the blonde
in the white convertible.
Have you seen me
cruising up the coast
on a mango day?
Top down, honeydew
bandana holding back
my hair, juicy fruit lips
smiling, enticing you
into a day dream?
Have you looked for me?
I am said to be elusive and
you may not recognize me.
I frequently slip into
something more comfortable
inside the round
gray-haired lady who
lives in the canyon
and writes poetry.

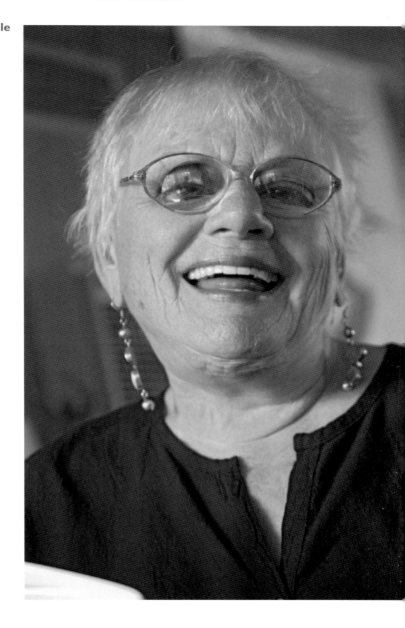

Trish the Dish

Trish Dugger is Encinitas' very own poet laureate. A member of the Full Moon Poets, 80-something Dugger is always one of the main attractions at La Paloma Theater when the 101 Artists' Colony sponsors the nationally famous twice-yearly Poetry Slam. It was at one of these events that the late Bob Nanninga introduced her as "Trish the Dish"—and the name stuck. One of the highlights of Dugger's poetic career came in 2005 when Encinitas City Council surprised her with a proclamation thanking her for her contribution to the community and citing, in particular, her "zeal and passion for poetry." But perhaps her proudest moment came in 2009 when she was asked to perform some of her "gently humorous" poetry at one of San Diego's premier literary events, the 16th annual Border Voices Poetry Festival in Balboa Park. (Photograph by Jim Babwe.)

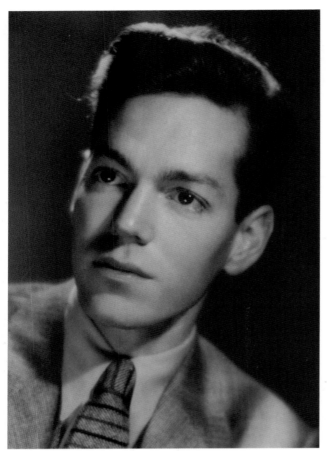

The Folks Who Live on the Hill
Hugh Martin, the last of the great composers from the golden age of American musicals, could often be found strolling along Neptune Avenue, making friends wherever he went. Best known for such legendary favorites as "The Trolley Song" and "Have Yourself a Merry Little Christmas," Martin joined forces with local historian Ida Lou Coley in composing "The Encinitas Song," which was revived in 2011 as part of the city's 25th anniversary celebrations.

Martin spent his last years living with Fred and Elaine Harrison (pictured, with actress Marsha Hunt) in their house overlooking the Pacific, and often laughingly referred to the three of them as "the folks who live on the hill." Martin died peacefully at age 96 shortly after publishing his autobiography, *The Boy Next Door*. (Courtesy of Elaine Lindsay Harrison.)

A Broader Canvas

What do Caesar's Palace, VG Donuts, and the San Diego Navy buildings have in common? They all possess at least one wall covered in a clever colorful mural by local artist Kevin Anderson. His smaller pictures, the portraits and seascapes, pop up in places like Captain Keno's, Encinitas café, and the American Legion, and are instantly recognizable as his inimitable artistry. Sometimes you might see Anderson on the beach, a lone painter with his dog and easel, quietly recording such phenomena as the unexpected appearance of hundreds of pelicans in flight. Five or so years ago, Anderson was a commercial illustrator in the advertising industry, but once computers started taking over he decided it was time to change direction. Life is less stressful now. "When I'm painting," he says, "I'm cool." Anderson is pictured here against the backdrop of the magnificent mural he painted on the side of the gas station in Leucadia. (Photograph by Kyle Thomas.)

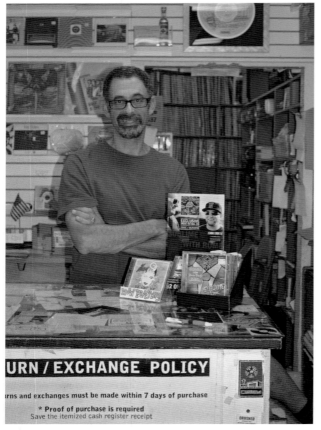

Swami Bruce

A self-confessed "non specialist," Bruce Stephens is eclectic in his interests and approach to life. He surfs, teaches ashtanga (eight-limbed) yoga, consults on organic and edible gardening, officiates at wedding ceremonies, and has even published a book—*The One True Fun*—of his surf prose and poetry. An enthusiastic supporter of the 101 Artists' Colony, Stephens also appears regularly at their poetry slams. (Photograph by Jim Babwe.)

Lou's Records

Since 1980, Lou Russell's store has been an amazing Aladdin's cave full of delights—new and used CDs, cassette tapes and vinyl, and things you feared you might never find again. Russell also hosts in-store musical performances for free, although by the third time he featured Jack Johnson, Russell found himself becoming a victim of his own success: over 3,000 people turned up—and so did the highway patrol. (Author's collection.)

Peaceful Easy Tempchin
The man who wrote "Peaceful Easy Feeling," along with a number of other legendary Eagles' hits, could easily choose to live anonymously. Instead, Jack Tempchin has been quietly committed to Encinitas ever since moving there in the late 1970s and has always been exceptionally generous with his time and talent when supporting local causes, such as the 101 Artists' Colony or Maggie Houlihan's Celebration of Life in May 2011 (bottom). For a while, Tempchin owned a bar in downtown Encinitas, where Willie Nelson once guested, and for 13 years he and his band, Rocket Science, were regulars at the Calypso Café in Leucadia. Closed down after a kitchen fire, this popular landmark re-opened in fall 2011, and Jack is back. (Photographs by Jim Babwe (top) and Dorell Sackett.)

One-Man Band

"An amazingly talented, funny, generous human being" is how Encinitas artist and writer Jim Babwe describes this legendary local. Steve White lost his battle with esophageal cancer in April 2011, a particularly cruel disease for someone who made his living singing the blues. A one-man band musical master, White could sing, play acoustic guitar, and accompany himself on harmonica, all the while producing complicated sounds from the percussion instruments at his feet. He often donated his time to help raise money for people he never knew, and it was this generosity that was returned in full when many of the region's best-known musical artists held fundraising concerts to help pay White's medical bills. Steve White's CD, *Home Away from Home*, recorded shortly before his diagnosis, was released posthumously on iTunes. (Photograph by Clint Burkett.)

Charlie Chaplin (RIGHT)

Nobody knows for sure how long the Little Tramp lived in his ocean-view home on Leucadia's bluff, or if indeed he ever did. He apparently bought the house for his mother in the mid-1920s, although some sources say she hated it and refused to stay there. The most plausible story seems to be that Charlie Chaplin used it to hide his supposedly-pregnant teenage bride far from the Hollywood gossipmongers— eventually succumbing to a costly divorce. But one thing is certain: "the Chaplin House" is still standing, despite the fact that, thanks to the computer-aided special effects in Steven Spielberg's comedy, *1949*, it appears to be sliding off the cliff-top into the unforgiving Pacific below. (Courtesy Lola Larson.)

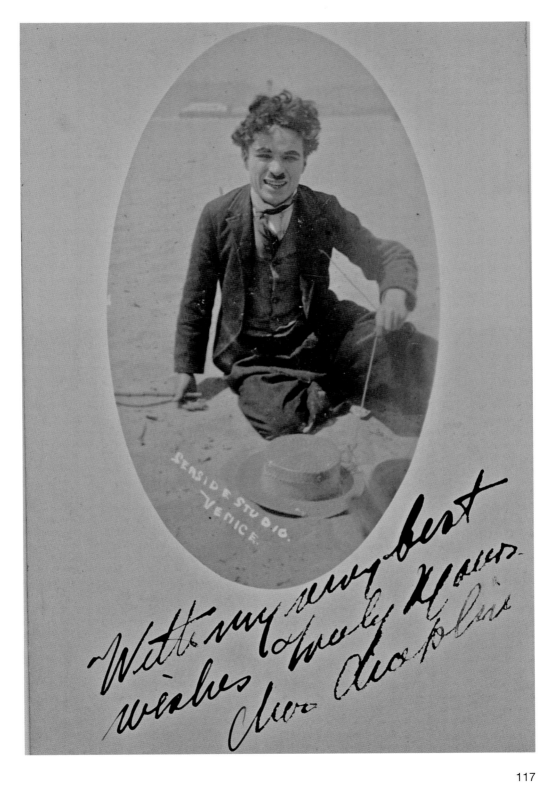

SEASIDE STUDIO
VENICE

With my very best
wishes truly yours.
Chas Chaplin

Dolphins

Danny Salzhandler is president of the 101 Artists' Colony, founder of the Full Moon Poets, and an essential component of the Encinitas community. Two years after being voted Citizen of the Year 2010, his crown has still not been toppled. Before arriving in Cardiff almost 20 years ago Salzhandler was, by turns, a construction worker, zookeeper, and Vietnam GI. He says he had never tried art before, but when he and his wife Norma left Texas to seek their fortunes in California, he decided it was time to get creative. Up in Orange County, an enormous buffalo stands as a shining example of Salzhandler's unique steel sculptures, while in a peaceful leafy garden by the Mammoth Buildings on Saxony Road, his towering dolphins, surrounded by plants, fountains, and jumping frogs, display a sinuousness you might never have expected from raw welded steel. (Author's collection.)

Circusmaster
The Encinitas 101 Artists' Colony is an artist-run collective that allows painters, poets, and performers to create and showcase their work. Danny Salzhandler is the one who holds it all together, even when it sometimes feels like a three-ring circus. Which is why, when Diane Carey Goth painted her banner, she topped Salzhandler's head with a ringmaster's hat. (Photograph by Dave Ombrello.)

Magic!
A descendant of the pioneering Hammond family, Joel Ward got hooked on magic at age six when he assisted a visiting magician at his Cardiff elementary school. By age 15, Ward had become a World Champion Teen Magician after placing first at the International Brotherhood of Magicians. In 2011, he pulled another rabbit out of the hat when he was a guest on Jay Leno's *Tonight Show*. (Courtesy of Joel Ward.)

David Brin

A longtime Olivenhain resident, Brin is a scientist, inventor, public speaker, and best-selling author, whose future-oriented novels include *The Postman*, inspiration for Kevin Costner's 1997 movie. Brin is also known as a leading commentator on modern technological trends, while his book, *Kiln People*, explores a fictional future in which its protagonists finally show us how to be in two places at once. (Photograph by Cheryl Brigham.)

La Paloma 1929 (BELOW)

The first Encinitas Flower Festival took place in February 1925, which explains the unusual number of cars parked along First Street. At the far end, on the right-hand side, the tower of the newly built La Paloma Theater is just visible. Although much has changed inside the theater since it was built, its classic Spanish Mission design has stood the test of time. (Courtesy of EHS.)

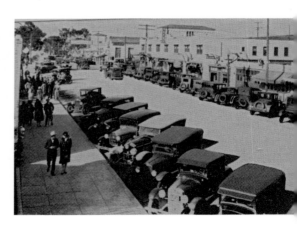

La Paloma 2011 (LEFT)

Legend has it that Mary Pickford rode her bicycle all the way from Rancho Santa Fe to Encinitas for La Paloma's Grand Opening on February 11, 1928, for the showing of *The Cohens and the Kellys in Paris*. Miss Pickford may be long gone, but the grand old lady of downtown Encinitas is still very much alive, with movies every night and special community events throughout the year. (Author's collection.)

Follies

Dave Oakley, who with his wife Margo is a leading supporter of civic programs in Encinitas, was one of the founding members, and a driving force, behind the recently disbanded Encinitas Senior Center Foundation. Formed in 1997 to offer financial aid during the center's construction, the foundation continued to offer substantial help even after the center opened in 2002, eventually contributing more than $120,000 toward the social enrichment and transportation of the city's seniors. The foundation's greatest fundraiser was undoubtedly its annual *Encinitas Follies*, held every February for 10 years at La Paloma Theater to sold-out audiences. The picture shows Oakley in 2004, with the reigning princesses from neighboring towns, at the start of the sixth annual *Follies*. (Courtesy of Dave Oakley.)

Boogie Chillun'

The last word that comes to mind when you think of Mary Fleener is garbage, but take a good look at the tile murals on the trashcans along Moonlight Beach or Neptune Avenue—both are Fleener's work. In fact, the woman on the boogie board mosaic by Leucadia's Grandview Stairs *is* Fleener. Although perhaps best known as an underground comix artist, she has also been part of the 101 Artists' Colony Arts Alive banner project for almost 10 years, was the first person to exhibit her ceramic artwork in the display boxes in the Encinitas Library lobby, and in 2010, organized its knockout "Artists by Artists" show where musicians, writers, and fine artists living in the Encinitas area produced portraits of one another in a variety of guises. Artists and models were matched up simply by picking names from a hat. The results were stunning.

Fleener is also very active in local politics and community activities. During her time on the Board of Leucadia Town Council, she joined forces in an Art Wars event with Jeremy Wright, a teacher at San Dieguito Academy, overseeing a dozen teenagers while they worked magic with paint and brushes on the side of the Leucadia Boulevard 7-11. Four years later, Fleener happily points out that their mural is still untouched by graffiti.

The above illustration, part of a 10-page story called "Boogie Chillun" comes from Mary's book, *Life of the Party*, and originally appeared in an anthology called *Twisted Sisters*. It tells the tale of how Fleener met a surfer, married a surfer, and eventually became one herself. (Courtesy of Mary Fleener.)

Local Guy Forever

Most days you can find Fred Caldwell at the back of Caldwell Antiques, his fabulously eclectic store on Highway 101, working on graphic design. Caldwell's brochures and bus wraps, retro 101 shields, and cast-iron tree grates have won countless awards, and he remains convinced that the flyers he designed for Maggie Houlihan's 2004 campaign were directly responsible for her landslide victory! Caldwell's annual *Magic Carpet Ride* calendar (pictured) featuring the Cardiff Kook's incessant wardrobe changes is as legendary as Caldwell. He admits to one stupid thing though: in 1985 he chased after a thief who had stolen a fishing knife from his store. The man suddenly turned on Caldwell and plunged the rusty four-inch blade straight into his heart. Fortunately, he survived. Encinitas without Caldwell would be unimaginable. (Top, Author's collection; left, courtesy of Fred Caldwell.)

Hearts of Stone

Diana Carey credits the Artists' 101 Colony and Full Moon Poets for the support and encouragement they gave her, during the 20 years she lived in Encinitas, to pursue her dream of succeeding as poet and artist. She has recently started working on abstract expressionist paintings on large canvases using the Pollock technique—deftly displayed here on her work clothes. Diana's earlier stonework under the pseudonym d.goth featured other frescoes with hearts broken and painted—and sometimes mended—which went national in sales. From there, she transitioned to other frescoes, mainly depicting people, doves, and religious iconography, taking her cue from the images that appeared in the cracks and crevices once she had broken the stone. This one is called *Release*. (Courtesy of Nadine Baurin.)

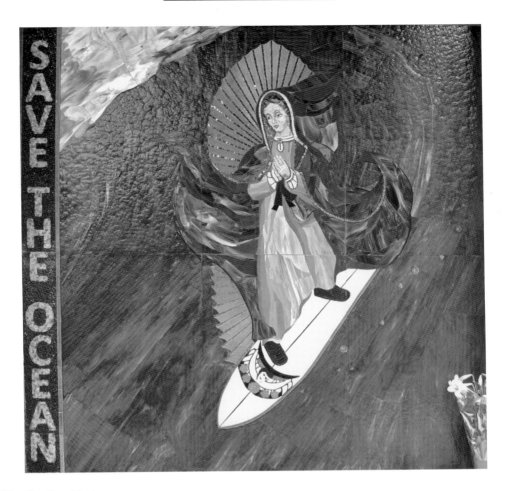

The Surfing Madonna

One sunny Friday afternoon, over the 2011 Easter weekend, two construction workers in white overalls labored behind canvas to attach eight panels to a concrete wall under the train trestle on Encinitas Boulevard. Nobody paid them any attention. But as soon as the tarps came down and the workers withdrew, Encinitas—indeed the world—took notice. What was revealed was a 10-foot-by-10-foot glass mosaic featuring Our Lady of Guadeloupe on a surfboard (goofy footed, surfers please note) with the words "Save the Ocean" running down the side. Almost immediately, the mysterious mosaic got nicknamed the Surfing Madonna. Most people considered it art, a few were offended by its sacrilegious nature, and the city council instantly labeled it graffiti. But whatever the reaction, the Surfing Madonna was seen as a symbol of modern Encinitas.

For almost two months, while the council wrestled with how to remove it, the anonymous artist with an environmentalist's agenda remained a mystery. Eventually, art consultants discovered his name running down one edge, and Mark Patterson, longtime Leucadia resident and ex-software employee, stepped forward to claim possession. Shortly afterwards, workers arrived to dismantle Patterson's beautiful mosaic and, by the end of June, the Surfing Madonna had disappeared as quickly as she had arrived. Although various local businesses have offered to find a place for the Surfing Madonna, at the time of writing she remains safely in Patterson's care. But such is her popularity that now and again he brings a panel or two to street fairs and the crowds, as ever, gather around in awe. (Courtesy of Fred Caldwell.)

Renaissance Man

Activist, environmentalist, prolific poet, and three-time city council hopeful, Bob Nanninga was a force of nature with an unwavering commitment to local issues. One of the many milieus that personified this renaissance man was the downtown E Street Café, which he and partner Keith Shillington opened in 2004 after being inspired to replicate the kind of interactive and "wired" coffee houses they had encountered throughout Europe and Australia. The constantly changing paintings on the café's walls showcased local artists, and the podium provided a platform for Nanninga's poetry readings and an open mike for many other performers.

An ardent conservationist, Nanninga founded Encinitas Environment Day in 2007, was an Encinitas parks and recreation commissioner, and served on the city's Invasive Species Subcommittee. Mary Fleener called him "a catalyst for all things creative" and this was evident in his involvement with the arts community: he taught theater in the Encinitas School District, was part of the Second Street Scene organizing committee and for 10 years acted as MC for the 101 Artists' Colony's poetry slams at La Paloma Theater.

Nanninga's regular *Coast News* column, "From the Edge," never pulled any punches, and his poetry was clever and imaginative. So far, Shillington has produced two volumes of Nanninga's work, one specifically aimed at children—or the child in us all—and has plans to publish more. Meanwhile, Nanninga's poem *Magic Carpet Ride*, part of which reads, "his story is our story, personified grace, both the past and the future, see yourself in his face," has been immortalized for all time on the base of the Cardiff Kook.

Nanninga's sudden and unexpected death on St. Valentine's Day 2009 left a huge vacuum in the lives of artists and environmentalists alike. The last editorial he sent the *Coast News* included this line from one of his poems: "make no mistake, I stand with the trees." He lies now beneath an oak tree, wrapped in the American flag. (Courtesy of Keith Shillington.)

In Memoriam

Bob Nanninga was such a fixture at La Paloma's poetry slams (left) that it was only fitting the theater be used for his memorial poetry reading. Jim Babwe who, along with Bruce Stephens, emceed the event, summed up his old friend with the valedictory words "tree hugger, mountain climber, mind sweeper, risk taker, peacemaker, boat rocker, status quo shaker." (Photograph by Jim Babwe.)